Giovanna Gaeta Bertelà

DONATELLO

SCALA/RIVERSIDE

CONTENTS

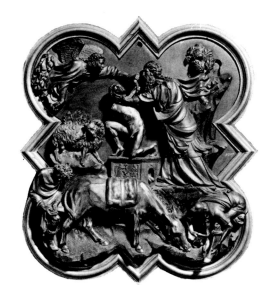

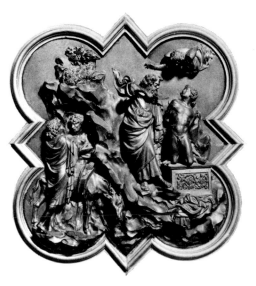

The illustrations for this volume come from the SCALA ARCHIVE, which specializes in large-format colour transparencies of visual arts from all over the world. Over 50,000 different subjects are accessible to users by means of computerized systems which facilitate the rapid completion of even the most complex iconographical research.

© Copyright 1991 by SCALA, Istituto Fotografico Editoriale, S.p.A., Antella (Florence)
Translation: Nancy Pearson and Anthony Brierley
Editing: Karin Stephan
Layout: Fried Rosenstock
Photographs: SCALA (M. Falsini and M. Sarri) except nos. 7, 91, 92, 93 (Opificio delle Pietre Dure, Florence); no. 41 (Archivio Pedicini, Naples); no. 42 (Musée des Beaux-Arts, Lille); no. 47 (National Gallery of Art, Washington); nos. 60, 61 (Musée Jacquemart-André, Paris); nos. 98, 99, 100 (Victoria and Albert Museum, London)
Photo type-setting: "m & m", Florence
Colour separations: RAF, Florence
Produced by SCALA
Printed in Italy by Lito Terrazzi, Cascine del Riccio Florence 1991

1, 2. Reliefs showing the Sacrifice of Isaac, executed by Lorenzo Ghiberti and Filippo Brunelleschi for the second door of the Baptistery Florence, National Museum of the Bargello

3, 4. The Prophets above the 'Porta della Mandorla' h. 128 and 131 cm Florence, Cathedral of Santa Maria del Fiore

The Early Years

Donato di Bardi, known to his family and friends as Donatello, was born in Florence probably in 1387. *He devoted his life to art, and proved himself an exceptional sculptor and a marvellous maker of statuary as well as a skilled and competent worker in stucco, in perspective, and in architecture, for which he was highly regarded. His work showed such excellent qualities of grace and design that it was considered nearer what was done by the ancient Greeks and Romans than that of any other artist. He is therefore rightly recognized as the first to make good use of the invention of scenes done in low relief, which he executed with thoughtfulness, facility and skill, demonstrating his intimate knowledge and mastery of the technique and producing sculptures of unusual beauty. He was superior not only to his contemporaries but even to the artists of our own times* (Vasari).

His first practical experience was gained in the Florentine workshops which in the late 14th century were at the peak of their activity, and as a young man he lived in a period of great significance for the development of new artistic movements. Side by side with the Gothic influence dominant in Florentine art at the turn of the 14th century there were signs of the evolution of a new artistic language, a fresh sensibility, and a new conception of man and his world. Lorenzo Ghiberti, born some eight years earlier than Donatello, was at this time the undisputed master in the field of sculpture, as shown by his victory in the competition organized in 1401 by the Arte dei Calimala (the Merchants' Guild) for the execution of a second door for the Baptistery. Taking part in the competition, whose subject was the *Sacrifice of Isaac*, were *Filippo Brunelleschi, Donatello, and Lorenzo di Bartoluccio (all Floren-*

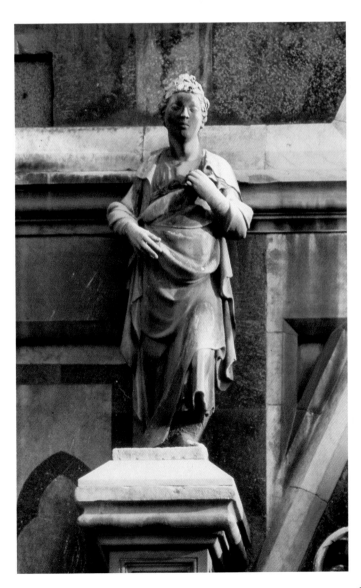

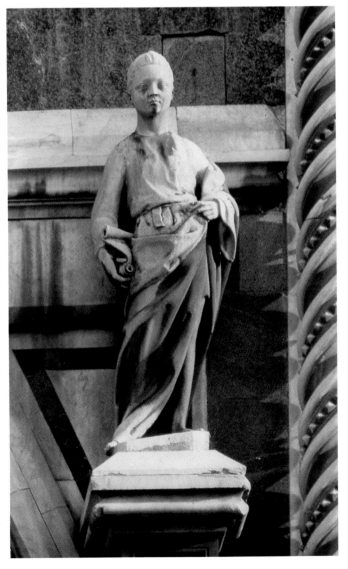

tines), Jacopo della Quercia of Siena, Niccolò Aretino his pupil, Francesco di Valdambrino, and Simone dal Colle, called Simone de' Bronzi. These artists promised to deliver their finished scenes by the stipulated time, and they set to work with great diligence and enthusiasm, exerting all their energies and knowledge to surpass one another and jealously hiding what they were doing lest they should copy one another's ideas (Vasari). In the competition Ghiberti's interpretation, with its smooth rhythm and strong accents of light and shade, was preferred to that of Brunelleschi, whose relief showed the new Renaissance concept of space and form as well as a mordent realism. *The whole work had design, and was very well composed; the finely posed figures showed the individuality of this style and were made with elegance and grace; and the scene was finished so carefully that it seemed to have been breathed into shape rather than cast and then polished with iron tools. When Donatello and Filippo saw the diligence with which he had worked they drew aside and determined between themselves that the commission should go to Lorenzo. In that way, they considered, both the public and the private interest would be best served* (Vasari).

In 1403 Donatello was employed in Ghiberti's workshop on the bronze relief of the north door of the Baptistery. He had already worked in other workshops and for other masters, none of whom had made any particular impression on him, but his apprenticeship to Ghiberti left an indelible mark. From Ghiberti he learned how to render the connecting surfaces clear cut and smooth, how to mould the background of his figures harmoniously and to treat drapery with an elegant and curved rhythm. He was impressed above all by Ghiberti's elegance, and it was the Gothic world therefore that influenced his earliest works.

From 1406 to 1408 he was working with Nanni di Banco in the workshop of the Cathedral of Santa Maria del Fiore, where for the Porta della Mandorla — one of the north doors of the Cathedral — he executed the so-called *Profetini*, two small statues of Prophets placed above Nanni's large bas-relief of the Assumption. Not all modern critics, foremost among them Janson, recognized these as the unmistakable work of Donatello, and in fact the two statues, although equally imbued with Gothic feeling, reflect different types of artistic experience: *the first figure* (to the left of the doorway) *shows more unmistakably the influence of Ghiberti's Gothic style, while the second* (to the right), *even in its arched rhythm, is closer to the classical dignity of Nanni di Banco*

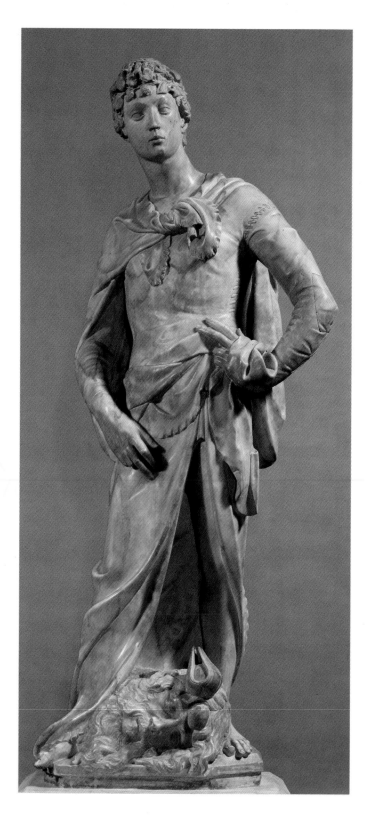

5, 6. The Marble David
h. 191 cm
Florence, National Museum of the Bargello

4

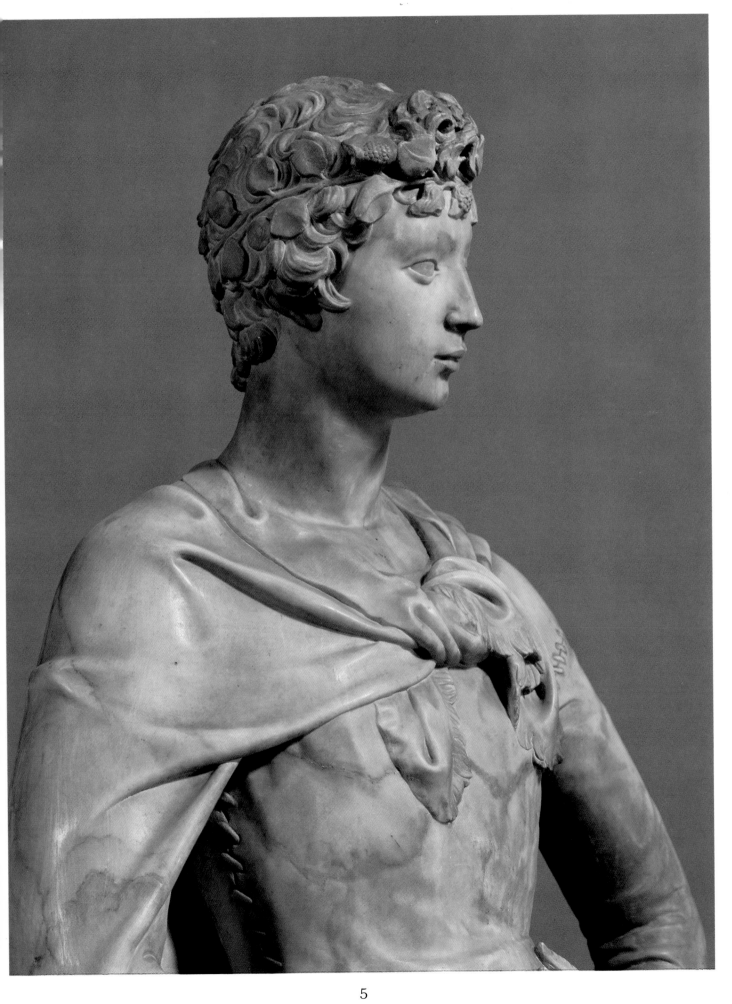

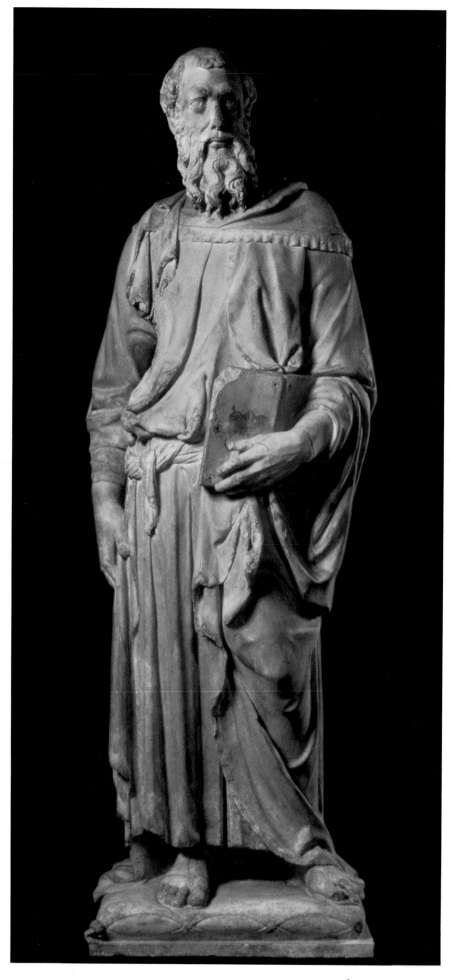

7. *St Mark (after restoration)*
h. 236 cm
Florence, temporarily at the
Opificio delle Pietre Dure

8. *St Mark in its original tabernacle*
at Orsanmichele (before
restoration)

9. *St Peter*
h. 237 cm
Florence, Church of Orsanmichele

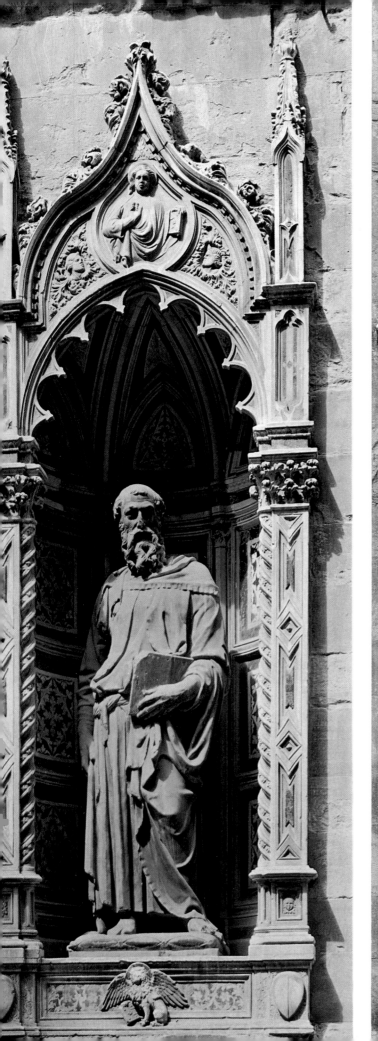
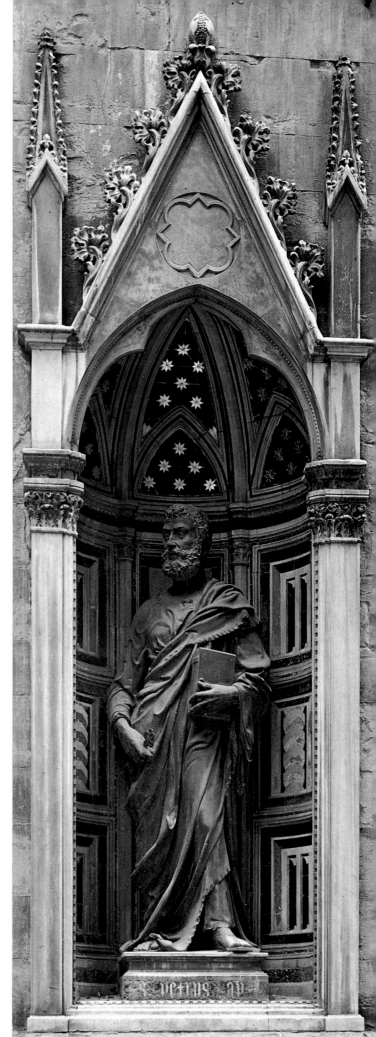

(Grassi) or *of the young Luca della Robbia* (Bellosi).

The same Gothic quality, although tempered by a moral intensity and a fierce spiritual pride foreign to Ghiberti, pervades the marble *David* of 1409 in the Bargello. Along with the *Isaiah* of Nanni di Banco this statue should have been placed on the lower frieze of one of the buttresses of the Tribuna of the Cathedral of Santa Maria del Fiore, but it proved too small for its intended site and in 1416 was moved to the Sala dell'Oriuolo in Palazzo Vecchio; it was transferred to the Bargello in the last century.

The emphasis on moral force, and the new idea of human dignity implicit in the Renaissance spirit, which can be felt in the youthful *David*, are even more apparent in the fine statue of *St Mark the Evangelist*, commissioned in 1411 by the Arte dei Linaioli (Guild of Linen Merchants) for the Church of Orsanmichele, *which, by agreement with Filippo Brunelleschi, he finished himself, though the commission had been given to both of them. Donatello displayed such great judgement in this work that those who lacked judgement of any kind quite failed to perceive its excellence and the consuls of the guild were reluctant to have it set up. Whereupon Donatello urged them to let him set it up on high, saying that he would work on it and show them an altogether different statue. When they agreed, he merely covered it up for a fortnight and then, having done nothing to it, he uncovered it and amazed them all* (Vasari). The solidity of the statue reflects classical rules. The weight of the figure rests on the right leg, and the left knee is slightly bent to maintain balance. Where it is not caught by the arm, the mantle falls to the ground in heavy folds, but it is in the imposing head, with its contracted brow and brooding eyes, that the character of the saint is expressed. Recently restored by the Opificio delle Pietre Dure (1990) and replaced by a marble copy, it is now waiting to be placed in a suitable museum.

As soon as the *St Mark* had been finished Donatello hastened to complete the *St John* which, together with the other Evangelists by Nanni di Banco, Niccolò Lamberti and Bernardo Ciuffagni, were to be placed *on the facade of Santa Maria del Fiore in the tabernacle at the side of the central door* (Antonio Billi). This statue, which was commissioned by the Opera del Duomo but executed much later — the payments go from 1413 to 1415 — almost seems to anticipate the works of Michelangelo. Particularly remarkable are the saint's acute and penetrating expression, and the realistic treatment of his open hand

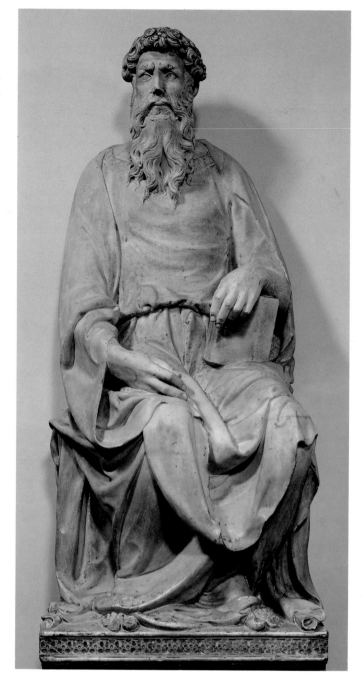

10, 11. St John the Evangelist
h. 212 cm
Florence, Museum of the Opera del Duomo

12. Crucifix
168 x 173 cm
Florence, Church of Santa Croce

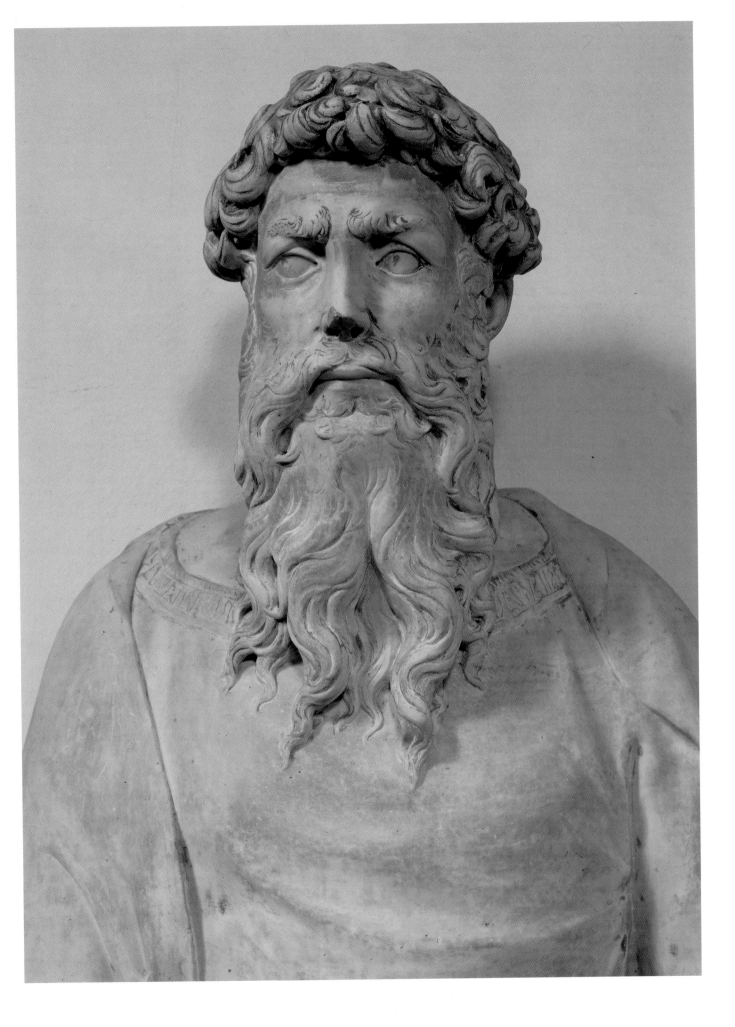

on the book. In 1587 the *St John*, along with the other *Evangelists*, was removed from the facade and placed inside the Cathedral, whence it was finally moved to its present place in the Museum of the Opera del Duomo.

The wooden *Crucifix* in the Church of Santa Croce is attributed to Donatello, although this attribution is not shared by all art historians. Adolfo Venturi, supported by Janson, considers it to be one of the artist's youthful works, executed, according to Antonio Paolucci, in a deliberate revival of the Ghibertian style which is exemplified by the *Crucifixion* panel on the north door of the Baptistery. The intensely life-like face of the dead Christ was not appreciated by Brunelleschi, who accused Donatello of having, in Vasari's words, *crucified a peasant*. But it reflects Donatello's creative force, his incessant search for new forms of expression, free from established rules, with which to experiment. It is unlikely that the first visit which Donatello and Brunelleschi made to Rome was in 1402, as Vasari affirms; it probably occurred some ten years later. Even though the classical world attracted him, and he applied classical rules of proportion to his statues, this was only another means of gathering intellectual and creative stimuli and constantly enriching his own art.

For the Armourers' Guild he made a very spirited figure of St George in armour, expressing in the head of this saint the beauty of youth, courage and valour in arms, and a terrible ardour. Life itself seems to be stirring vigorously within the stone (Vasari). The youthful period of Donatello is thus typified by his *St George*. This statue, executed around 1416, was placed in a niche on the north wall of Orsanmichele. The tensed expression of the young face shows its affinity with the ideal of *David* in the Bargello. The cloak gathered over the chest in a tight knot falls in folds whose spiral line retains an echo of the Gothic world, as does the position of the statue in its niche. But the problem of space has been overcome, and the *St George*, turning on the axis of the shield, moves with a great visionary force. *And to be sure no modern statues have the vivacity and spirit produced by nature and art, through the hand of Donatello, in this marble. On the base of the shrine he carved a low relief in marble of St George killing the dragon, with a horse that is very highly praised and regarded; and in the frontal he made a half-length figure of God the Father, again in low relief* (Vasari). The base of the niche, with the bas-relief representing the saint's combat with the dragon for the freeing of the Princess of Cappadocia, also assumes a role of great impor-

tance due to the artist's use of the technique known as *rilievo stiacciato*, or flattened relief. It is the first example of a long series of scenes in which the artist applied techniques characteristic of medal-making, painting and drawing, to relief in marble. The shallowness of the cutting enabled Donatello to place figures in movement against a landscape, in which careful attention to linear perspective created an illusion of space. Once more Donatello was experimenting with new forms of artistic expression unknown to either the classical or Gothic worlds.

The positive appraisal of the *St George* in the 16th century is borne out by the writings of Vasari. Subsequently mentioned in Anton Francesco Doni's *I Marmi*, when it is compared with Bandinelli's *Hercules and Cacus*, and with Michelangelo's *David*, the *St George* even surpasses the great sculptures of Piazza della Signoria. Later, Francesco Bocchi's essay, the *Eccellenza della statua del San Giorgio*, written in 1571 for Cosimo de' Medici and published in 1584 with a dedication to the Accademia Fiorentina del Disegno, was perhaps the first monograph on an "ancient" monument that still retained its importance and its role, thanks to its characteristic setting. In later centuries, when Donatello's works were generally ignored or mentioned only in local guides, the transfer (after 1677) of the statue of *St George* to the tabernacle of the Arte dei Medici e Speziali (made for the *Madonna della Rosa*), contributed to the diminishing of its beauty and therefore its fame.

Despite the praise of Pelli, who adhered to Vasarian tradition, it was Leopoldo Cicognara who rediscovered Donatello, lauding mainly the variety of his techniques and the classical revival of ancient forms. The *St George* drew on antiquity, and as a new hero the figure was as inspiring as a Jupiter or a Laocoon. In 1837 Andrea Francioni drew the attention of young people to Donatello as a moralistic example and interpreted the *St George* as the *model of the sobriety and depth of its author*. Thus the *St George* marked *art's greatest step from the ancient to the modern*: the now defined masterpiece of Donatello was about to become the emblem of early Renaissance statuary.

In the second half of the 19th century the reappraisal of Renaissance sculpture led Donatello to be regarded as the passage from medieval traditions to those of modern art. It was in this context that Florence celebrated the quincentenary of Donatello's birth in 1886, and interpreted the *St George* as the heroic-religious symbol of sacred and civil virtues. And although the statue failed to

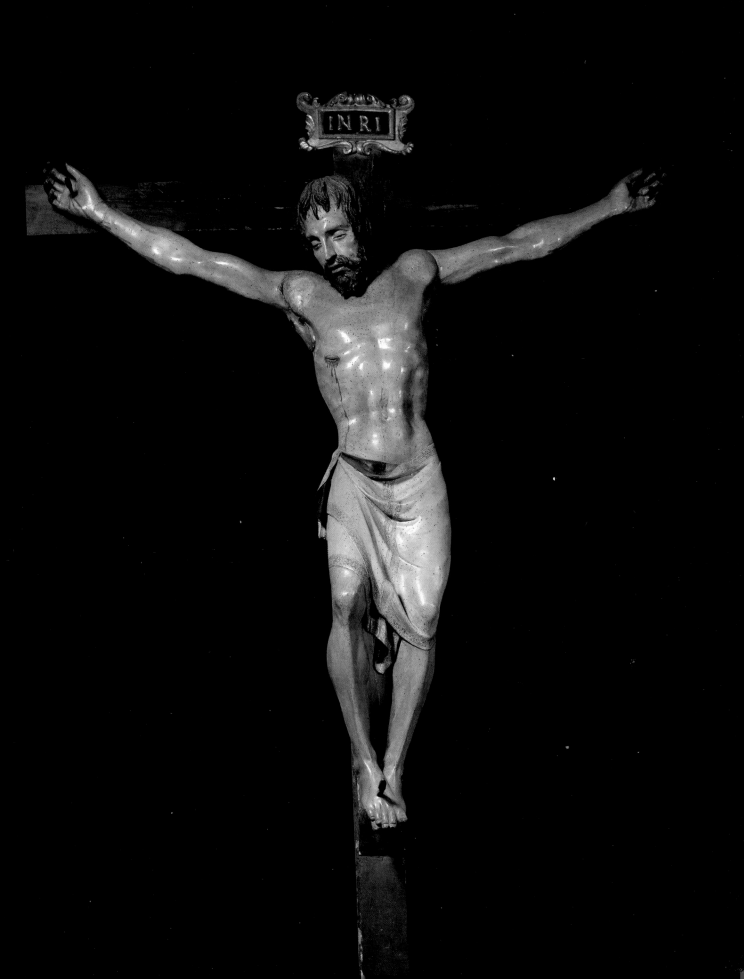

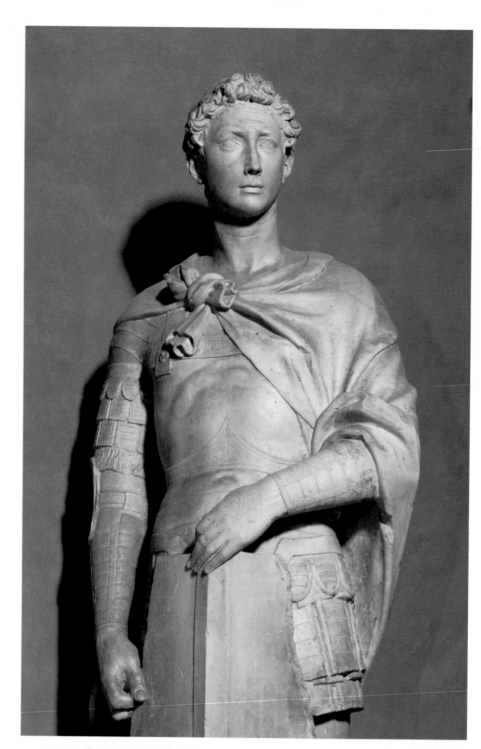

13, 15. St
George
h. 209 cm
Florence,
National
Museum of the
Bargello

14. St George
and the
Princess
38 x 120 cm
Florence,
National
Museum of the
Bargello

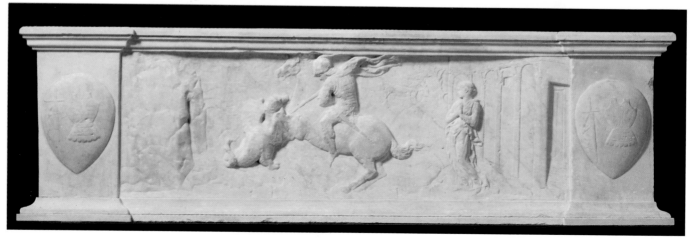

12

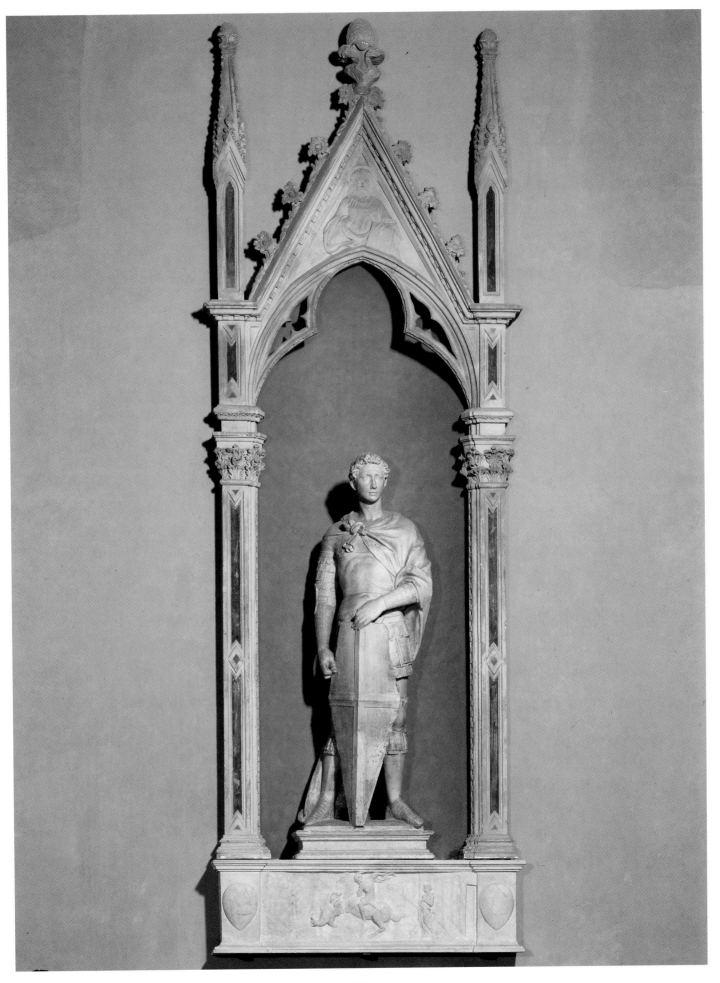

13

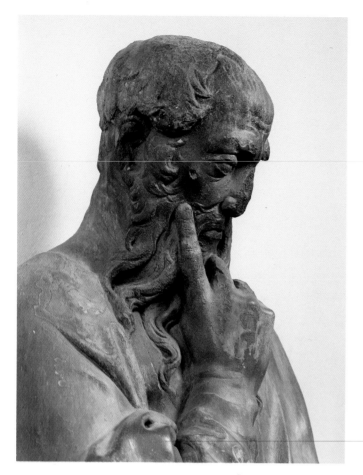 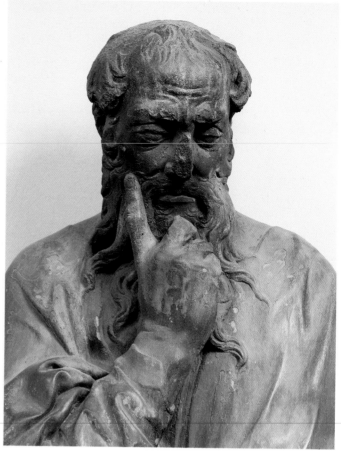

appear in the "gran sala" of the Bargello for the artist's centenary, appearing instead in the photographic section, its transferral to the museum was now imminent. In January 1892 the *St George* was finally placed in the false niche of the National Museum and replaced by a bronze copy, while a plaster model, which was used in casting it, was exhibited at the Institute of Fine Arts. The relief of *St George and the Princess*, which remained on the facade of Orsanmichele, deprived the figure in the Bargello of a fundamental bond. Not only would atmospheric agents contribute to the decay of the bas-relief's physical condition, but the soluble salts contained in the rainwater running off the bronze copy itself would exacerbate the corrosion of the base underneath. In 1976, by then too late, the bas-relief of *St George and the Princess* was removed and taken to the Opificio delle Pietre Dure for the appropriate restoration. In 1985 it was finally reunited with the *St George* in the Bargello.

Only a short period of time separates the *St George* from the first sculptures executed by Donatello for the Campanile of the Cathedral of Santa Maria del Fiore. They comprise the *Bearded Prophet*, the *Prophet with Scroll*, and *Abraham and Isaac*, which are now housed in the Museum of the Opera del Duomo. Compared with the *St George* this group has a completely different emphasis. The *Bearded Prophet* conveys a potential freedom of movement unthinkable in the works of Donatello until this moment, and in the extraordinarily realistic treatment of his face the *Prophet with Scroll* is a man weighed down by thought. The group of *Abraham and Isaac*, recognized in part as the work of Nanni di Bartolo, reveals yet another step forward in the conquest of vertical space, and is further proof of Donatello's ceaseless experimentation. Space here is not divided up mathematically as it is in the *St George* but is broken into innumerable points of view.

With the same purpose and during the same years Donatello executed the *Marzocco*, the emblem of the city of Florence. It was mentioned in the archives of Santa Maria del Fiore as *a stone lion to be placed on top of a column of the stairs of the Pope's apartment* in Santa Maria Novella, for the visit to Florence of Pope Martin V in 1419. The silence of Vasari and his followers exerted such a negative influence that the sculpture became well-known only in the last century, when it was placed in front of Palazzo Vecchio in 1812. It was moved to the Bargello National Museum in 1865.

With the *St Louis* of Orsanmichele (a gilded bronze statue from the Museum of Santa Croce, where it suffered slight damage in the flood of

1966), we are confronted with a turning-point in Donatello's maturity. The search for a naturalistic rendering was intensified: in the *Bust of St Rossore* of the National Museum of San Matteo in Pisa, in the *Monument to John XXIII* from the Baptistery of Florence, reaching its highest point in the *Prophet Jeremiah* (1423-26) and the *Prophet Habakkuk* — the so-called *Zuccone* (pumpkin-head), and ending in the 1440s with Donatello's participation in the decoration of the Campanile. In all these works unrealistic elements have been discarded. See, for example, the *Bust of St Rossore*, where the intimism and clearly defined features of the face, with its knitted eyebrows, have led some scholars to assume that this is Donatello's self-portrait. But even regarding the work as a reliquary bust, this became the prototype of Renaissance portrait busts. The reclining statue of the anti-pope John XXIII, Cardinal Baldassarre Coscia, who died in Florence in 1419, is also realistically rendered in the facial details and the deep folds of the garments; it lies under the high baldachin of Donatello (who, together with Michelozzo, was responsible for the architectural conceptualization of the whole monument). If the realism had become accentuated, the sense of motion had grown, and the relationship between figure and space had become even more apparent, this rapport now became increasingly detailed and reached its full flowering in the reliefs, where through the *rilievo stiacciato* Donatello was able to give free rein to his skill in picture-making.

In 1425 Donatello had already begun the *Herod's Banquet* for the Baptismal Font in the Cathedral of Siena, for which, as early as 1417, two reliefs, one of the *Baptism of Christ* and the other of the *Arrest of St John*, had been ordered from Ghiberti. We know from documents that *Herod's Banquet* in its finished state reached Siena on 13 April 1427. In its style this relief represented a further development of the motifs expressed in that of *St George and the Princess*, and foreshadowed the bronze bas-reliefs on the High Altar of the Church of St Anthony in Padua. The small statues of *Faith* and *Hope*, executed between 1427 and 1429 for the corner of the Font, show a lyrical grace that is different from the relief of the *Herod's Banquet*, suggesting that his temporary collaboration with Ghiberti on the decoration of the Font may have caused Donatello to return to earlier methods of expression that had long been abandoned. But these two statues are a mere interlude. In the works that followed — the *Tombstone of Bishop Giovanni Pecci* in the Cathedral of Siena, signed and dated 1426,

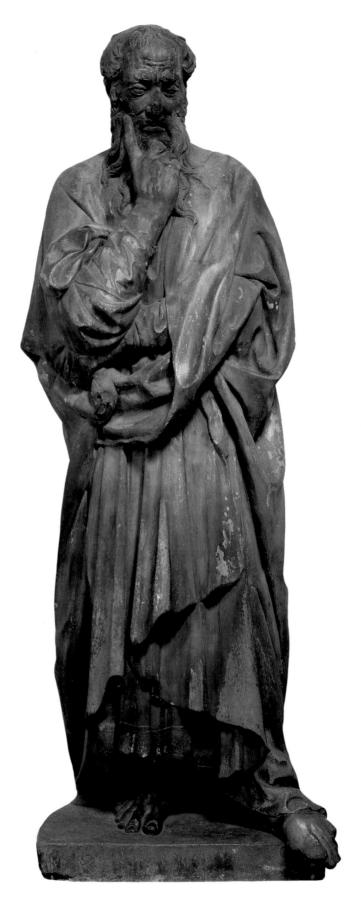

16-18. Bearded Prophet
h. 194 cm
Florence, Museum of the Opera del Duomo

15

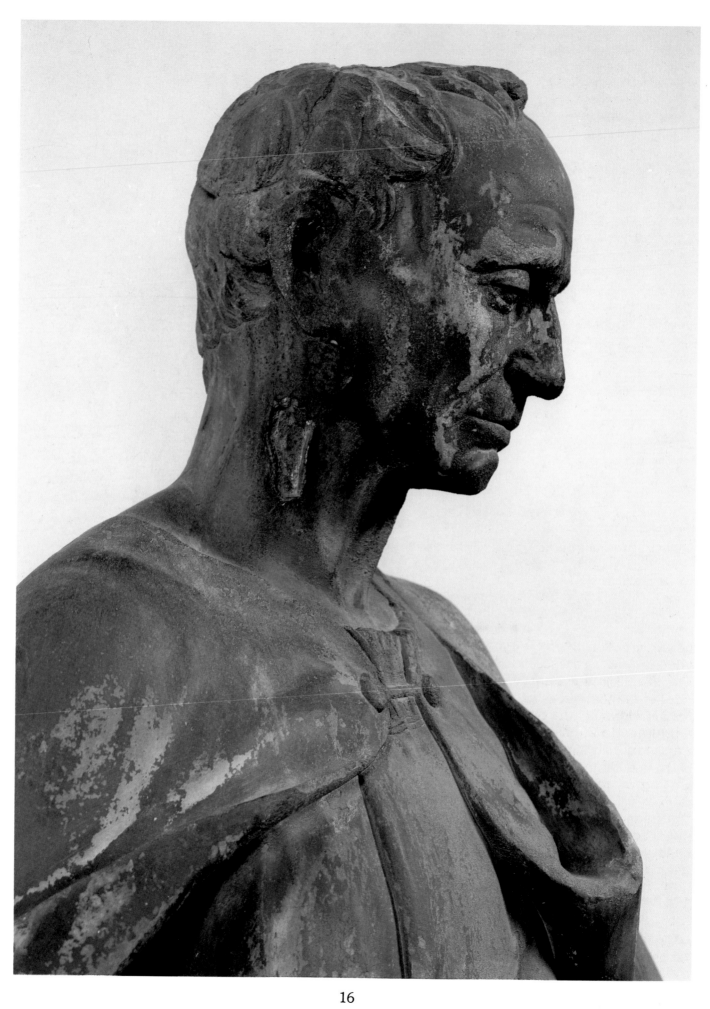

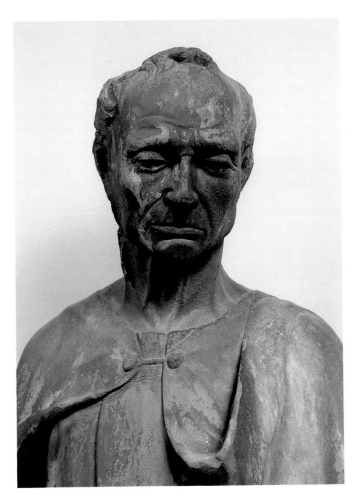

19-21. Prophet with Scroll
h. 195 cm
Florence, Museum of the Opera del Duomo

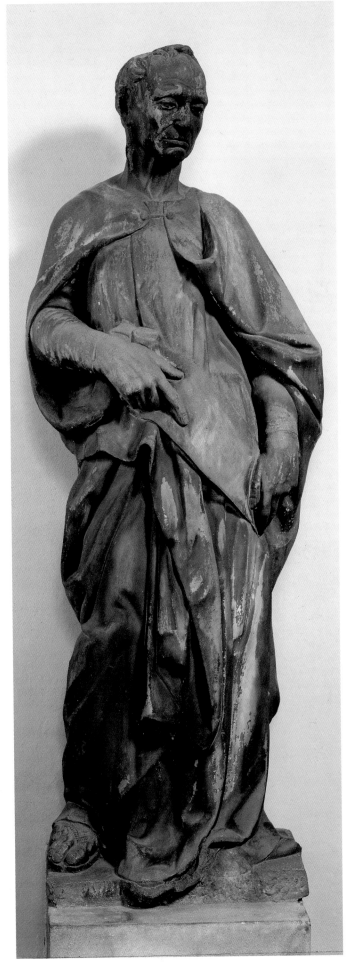

the *Assumption of the Virgin* carved in Pisa in 1427 for the Brancacci tomb in Sant'Angelo a Nilo (Naples), the *Christ Giving the Keys to St Peter* of the Victoria and Albert Museum, and the *Pazzi Madonna* of the Berlin Museum — Donatello returned to the flattened relief, pushing its expressive possibilities to the utmost limits.

The meeting with Masaccio, who in 1429 was working on the *Carmine polyptych* in Pisa, undoubtedly influenced Donatello, leading him to explore more deeply the problem of perspective and space.

Moreover, the same rules of two-point linear perspective, which Leon Battista Alberti codified in his *De Pictura* in 1435, also guided Donatello in this direction. This is attested to by the *Herod's Banquet* of the Musée des Beaux-Arts in Lille (once part of the collections belonging to Lorenzo the Magnificent); Salomé, who in the act of dancing expresses her dramatic tension — within an

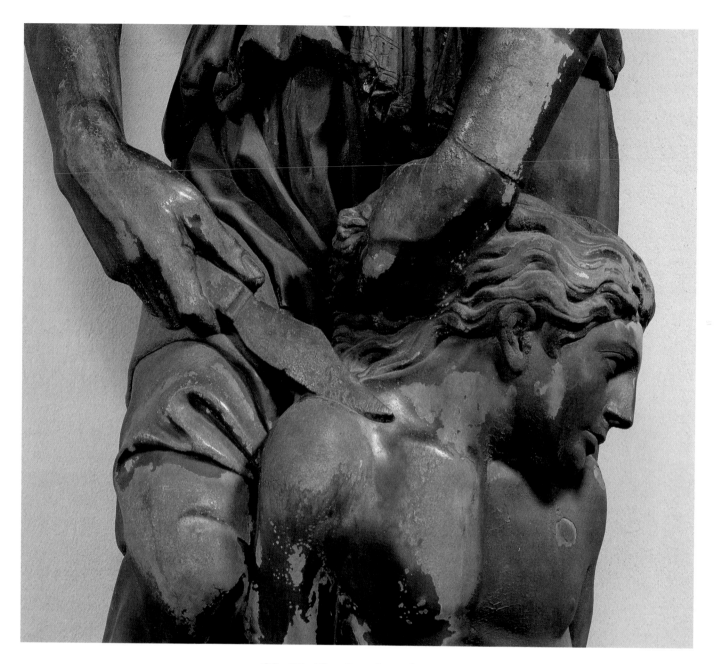

22, 23. The Sacrifice of Isaac
h. 191 cm
Florence, Museum of the Opera del Duomo

imaginary architectural structure — is a demonstration of Alberti's instructions and causes the narrative content to blend into the architectural representation.

The first part of Donatello's artistic activity ends around 1430 with the bronze statue of *David*. It was originally placed in the courtyard of the Medici-Riccardi palace, but after the confiscation of the Medici palace in 1495 it was moved to the courtyard of Palazzo Vecchio and placed on a marble column. It remained there until 1555 when it was replaced by Verrocchio's fountain and moved to a niche on the left of the door. In the 18th century it was moved to the Guardaroba, in 1777 to the Uffizi, and from there was transferred to the Bargello, where it can be see today. The *David* shows Donatello's elegant handling of Praxiteles' idea of form. But if the artist turned to antiquity for the representation of the nude and for the static balance of the composition, the vitality which animates the statue, from the thoughtful young face shaded by the winged helmet to the severed head of Goliath, is entirely new. The light activates lines which dart with extreme fluidity from whatever the observer's point of view. Vasari's description is illuminating: *In the courtyard in the palace of the Signoria stands a bronze statue of David, a nude figure, life-size; having cut off the head of Goliath, David is raising his foot and placing it on him, and he has a sword in his right hand. This figure is so natural in its vivacity and softness that artists find it hardly possible to believe it was not moulded on the living form. It once stood in the courtyard of the house of the Medici, but was moved to its new position after Cosimo's exile.* The traditional interpretation of a victorious David has today been supplemented by that of a Mercury standing over the head of a decapitated Argus (almost an allegory of Truth overcoming Envy) which is believed to have been executed shortly before the middle of the century.

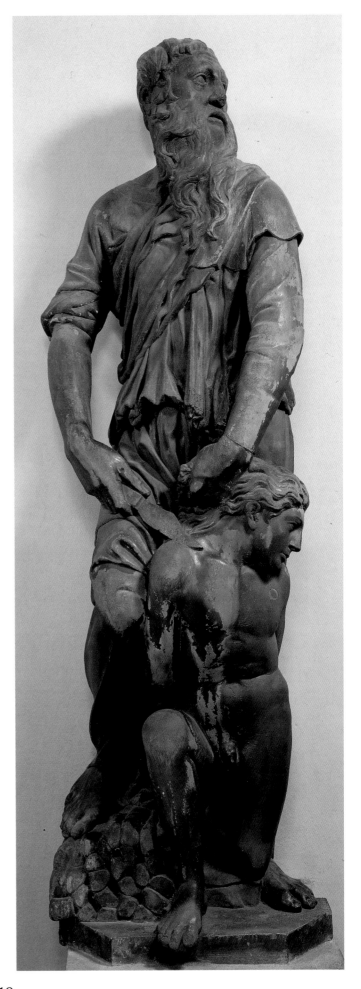

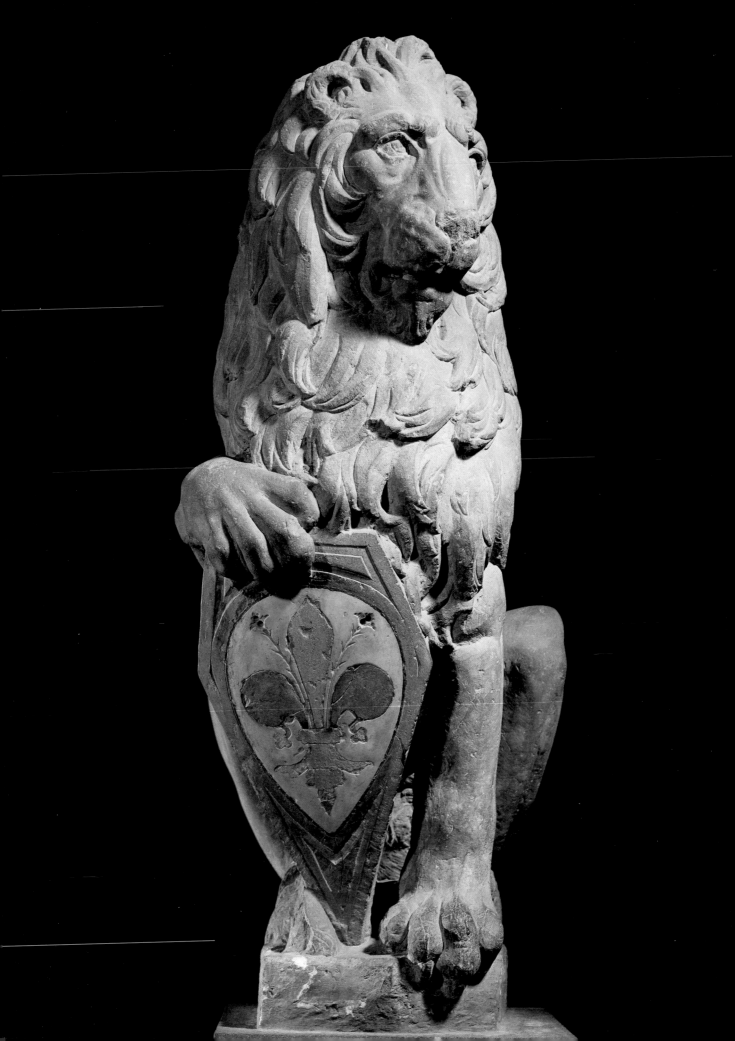

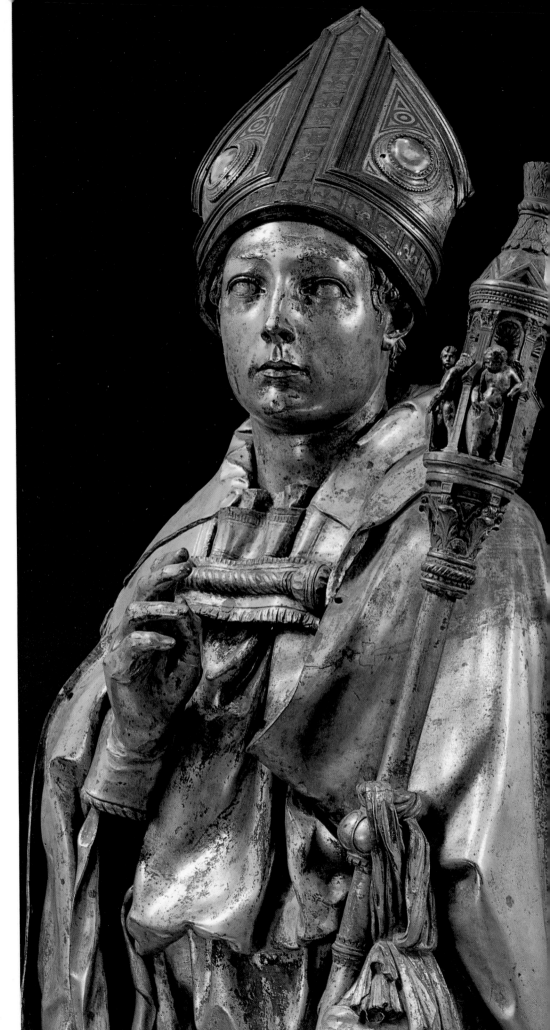

24. The "Marzocco"
h. 135.5 cm
Florence, National
Museum of the Bargello

25. St Louis, detail
h. 266 cm
Florence, Museum of the
Opera di Santa Croce

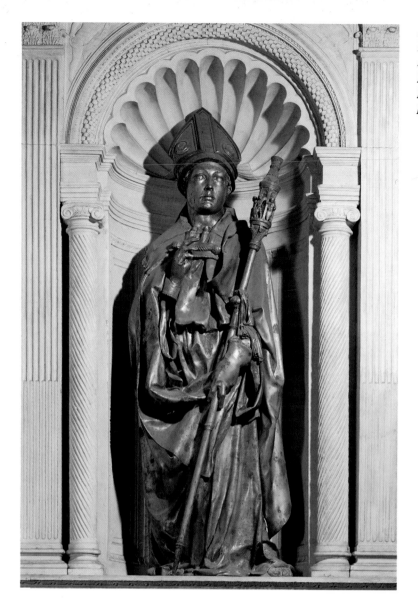

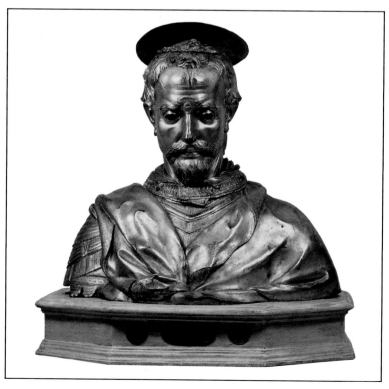

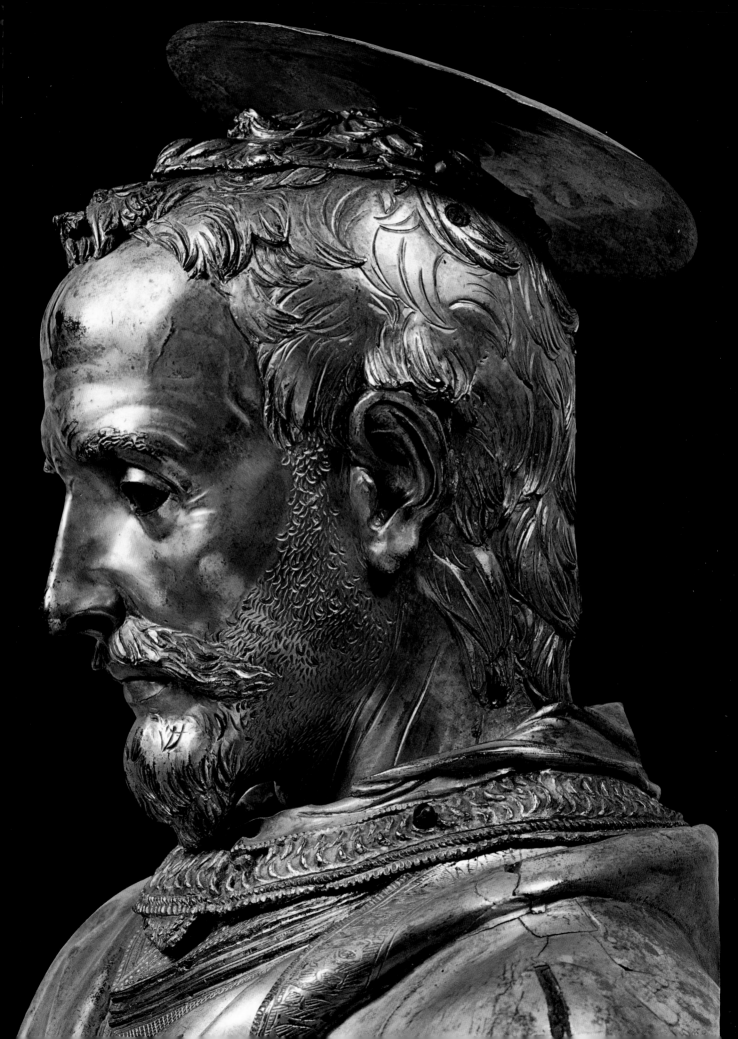

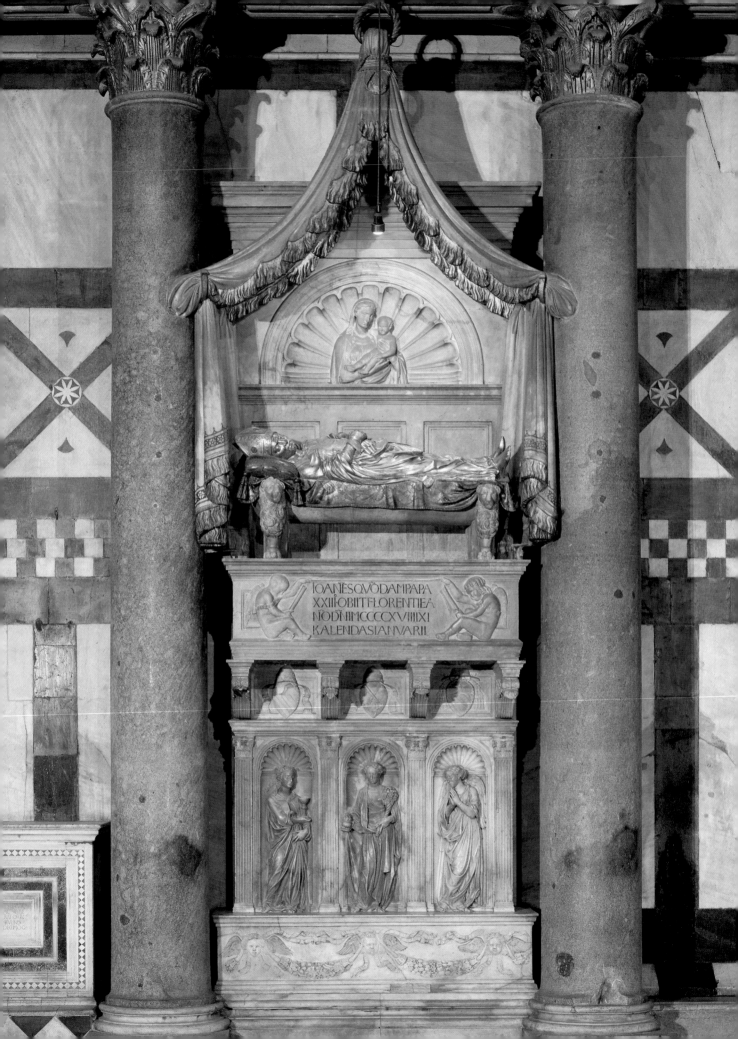

IOANESQVODAMPAPA
XXIIIOBIITFLORENTIEA
NODNIMCCCCXVIIIIXI
KALENDASIANVARII

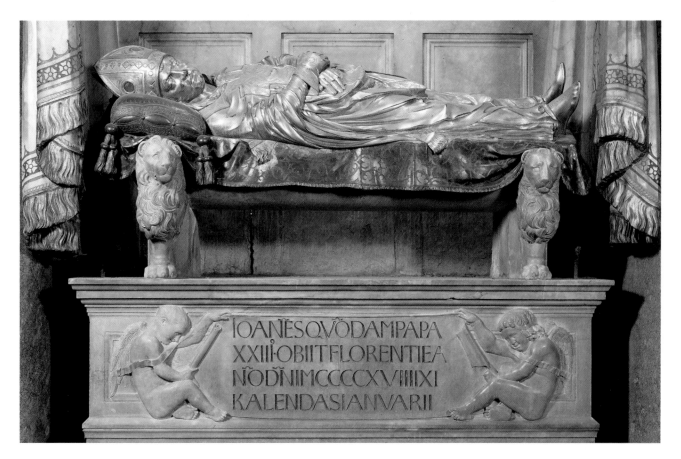

IOANĒSQVŌDAMPAPA
XXIII·OBIITFLORENTIEA
ÑODÑIMCCCCXVIIIIXI
KALENDASIANVARII

29. Donatello and Michelozzo
Funeral monument to John XXIII
Florence, Baptistery

30, 31. Funeral monument to John XXIII,
detail of the statue of the anti-pope by Donatello
and of the relief showing the Virtues by
Michelozzo

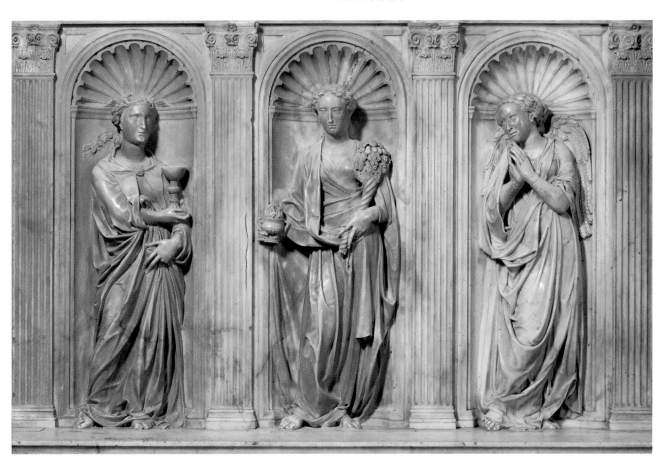

25

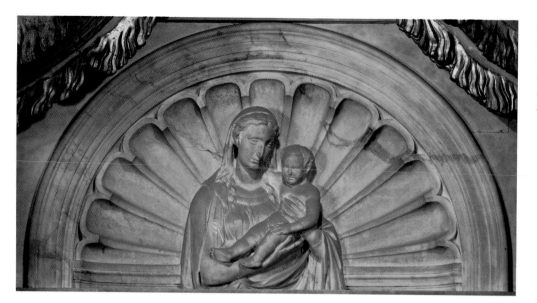

32. Funeral monument to John XXIII, detail of the lunette with Madonna and Child by Michelozzo Florence, Baptistery

33, 35. The Prophet Jeremiah h. 193 cm Florence, Museum of the Opera del Duomo

34, 36. The Prophet Habakkuk h. 196 cm Florence, Museum of the Opera del Duomo

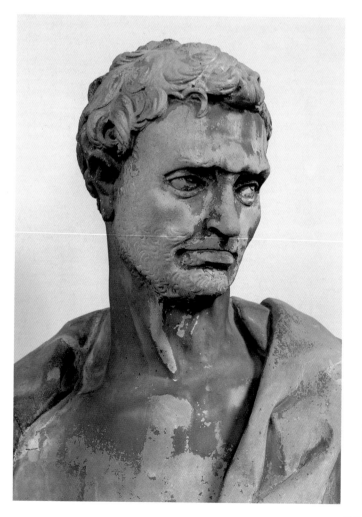

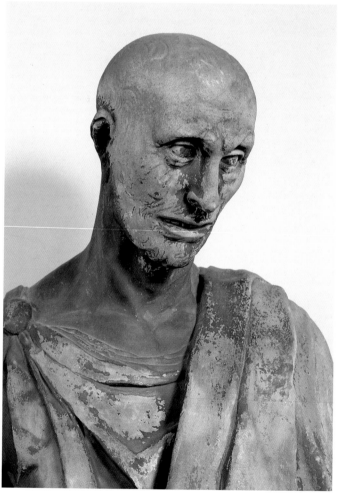

26

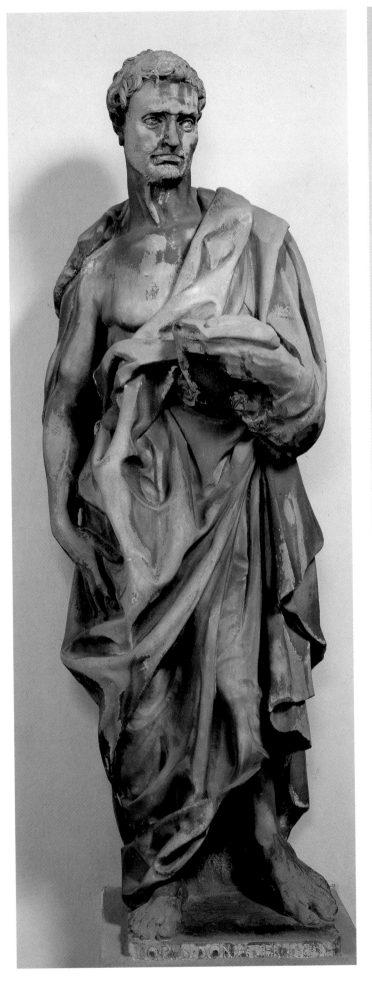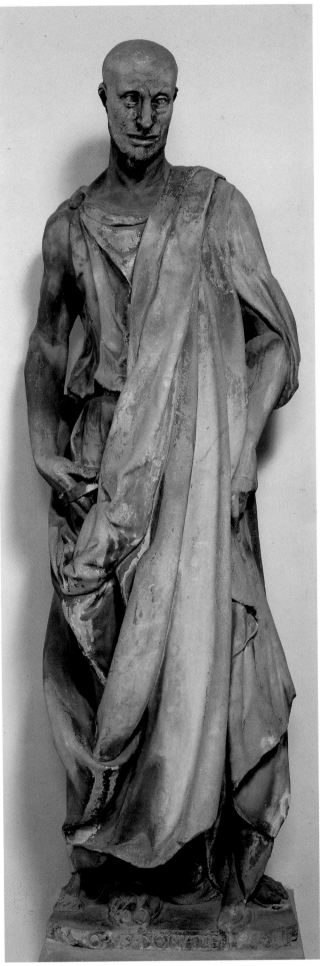

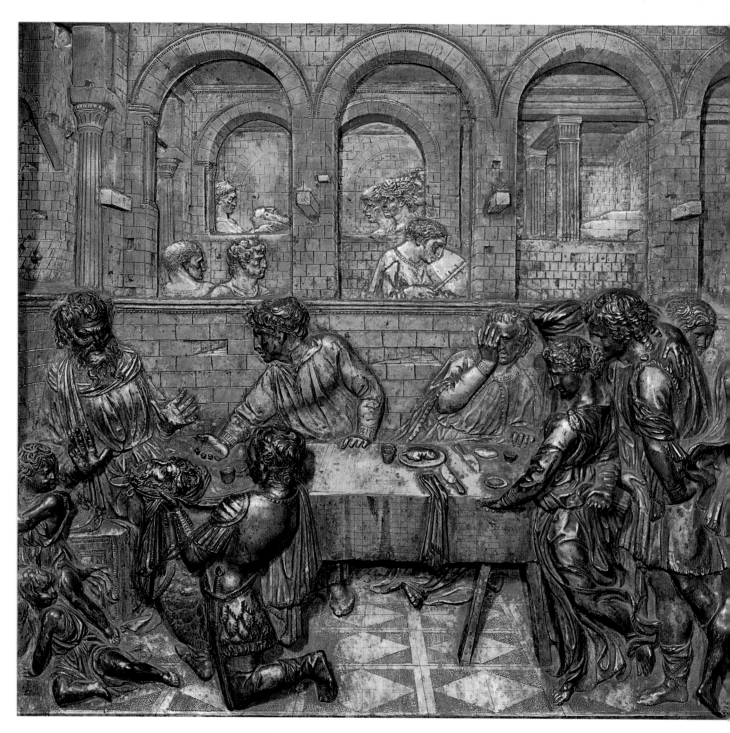

37. *Herod's Banquet*
60 x 60 cm
Siena, Baptistery

38. *Faith*
h. 52 cm
Siena, Baptistery

39. *Hope*
h. 52 cm
Siena, Baptistery

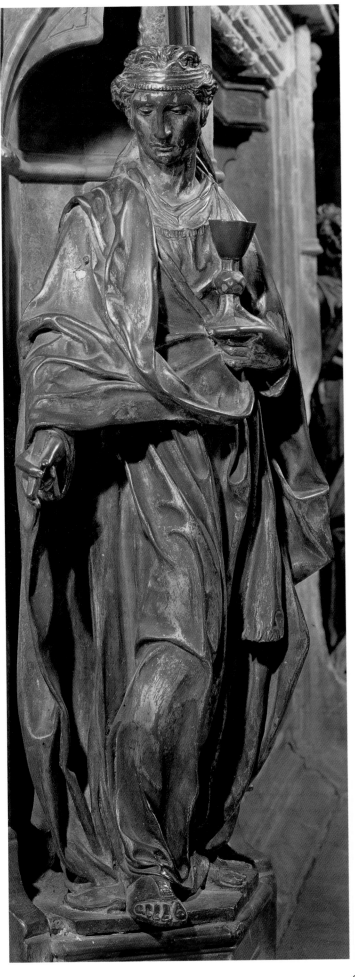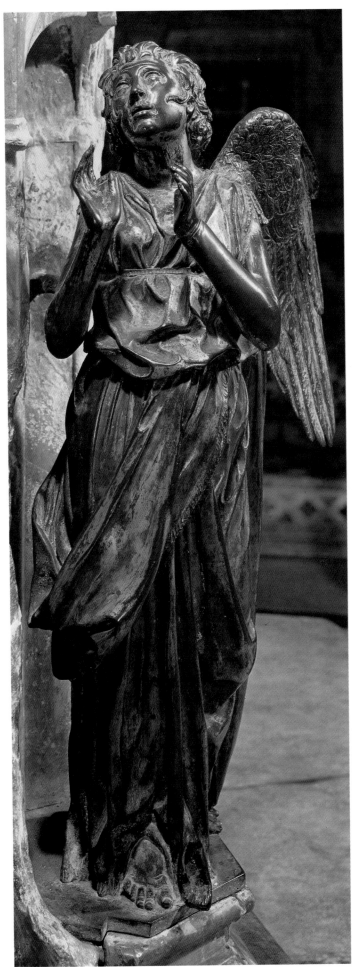

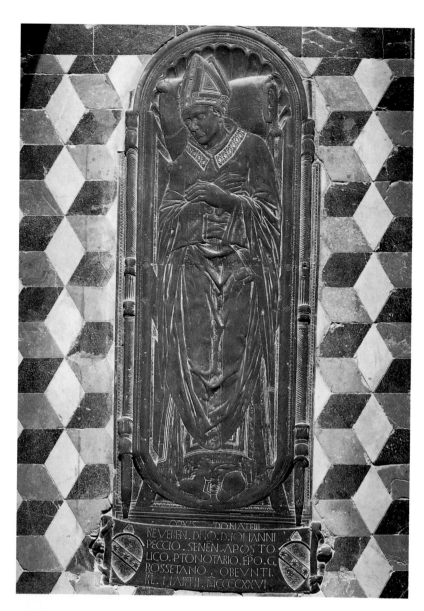

40. Tombstone of Bishop Giovanni Pecci
247 x 88 cm
Siena, Cathedral

41. Brancacci Tomb, detail of the Assumption of the Virgin
53.5 x 78 cm
Naples, Church of Sant'Angelo a Nilo

42. Herod's Banquet
43.5 x 65 cm
Lille, Musée des Beaux-Arts

43-45. The Bronze David
h. 185 cm
Florence, National Museum of the Bargello

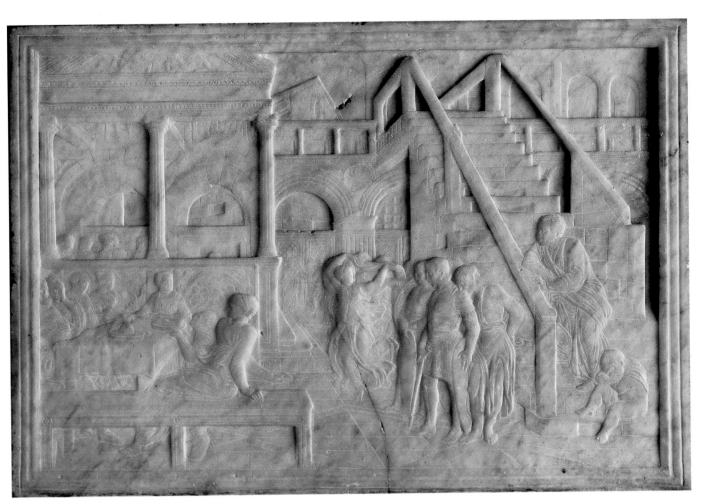

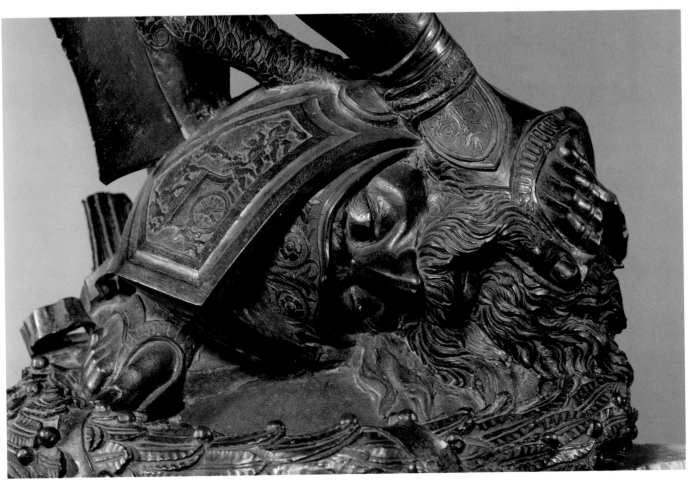

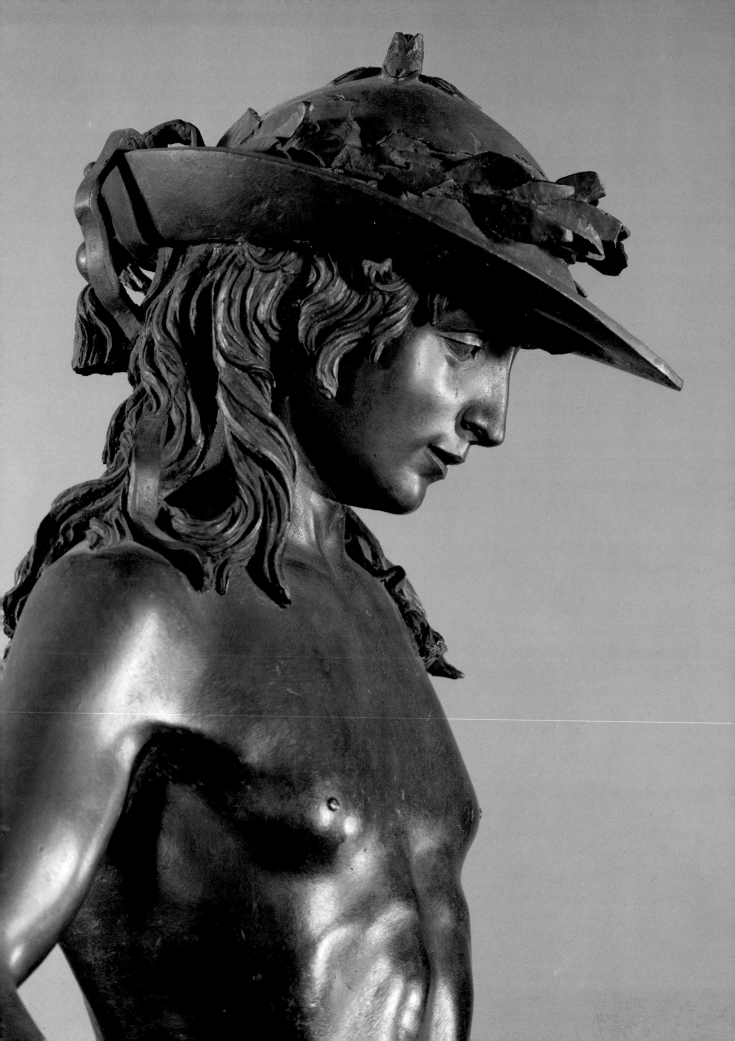

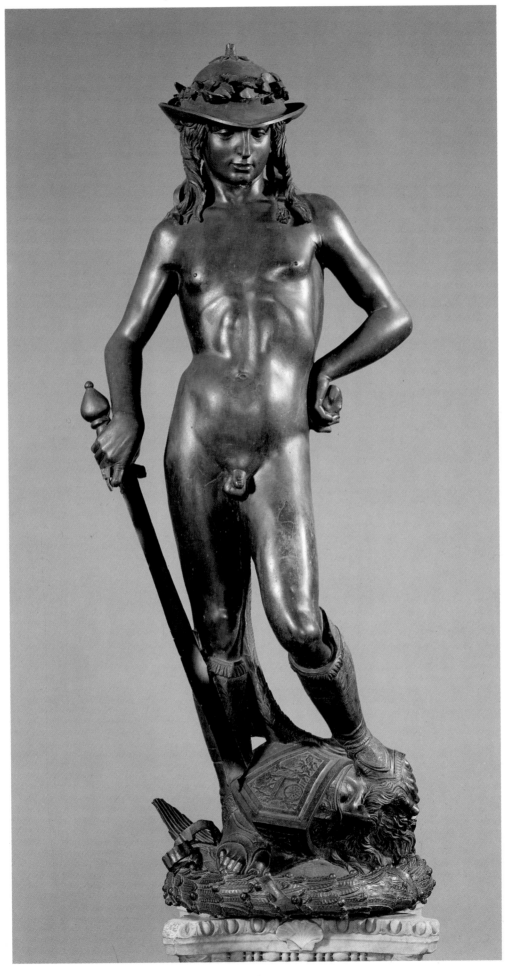

33

Artistic Maturity

Following the restoration of 1985, the polychrome terracotta *Bust of Niccolò da Uzzano* in the Bargello, originally from Palazzo Capponi, has won back its place in the history of Florentine Renaissance sculpture which Carlo Carlieri had assigned to it in his *Florentine Guide* of 1745.

This distinguished public figure, who led the party which opposed the Medici, and represented several times in fresco (in the Church of Santa Maria del Carmine, in Palazzo Medici-Riccardi, in the Church of Sant'Egidio), on medals and subsequently in the commemorative alcoves of the Uffizi Gallery and even in the 'Serie Gioviana', could not be ignored by the young Donatello, who reproduces the man in polychrome terracotta, in line with the classical model of antiquity. Probably executed in the 1430s (Niccolò died in 1433), it reveals the physical and moral individuality of the man, and has been described as *the oldest half bust portrait of the Florentine Renaissance* (Pope-Hennessy).

Donatello's second visit to Rome took place between 1432 and 1433. The artist returned to Florence not only with a vivid impression of classical and Hellenistic works but also with a strong admiration for the brilliant effect of the medieval Cosmatesque decoration in coloured mosaic that he had observed in many Roman churches. In the few works which he executed in Rome — the *Tombstone of Giovanni Crivelli* in the Church of Santa Maria Aracoeli, and, in collaboration with Michelozzo, the *Tabernacle of the Sacrament* in St Peter's, there is no evidence of this influence, which however became very marked in the works he executed in Florence during the ten years that followed his visit. This was a fertile period marked by a substantial output. It comprises an unfinished marble *David*, now in the Washington National Gallery and — probably worked on between 1432 and 1434 — the *Annunciation* of Santa Croce, the marble panels of the *Pulpit* in Prato, the *Cantoria* of Florence Cathedral, the *Amor-Atys* in the Bargello, the *Bust of a Youth*, and the decoration of the *Old Sacristy* of San Lorenzo.

The *Annunciation* in Santa Croce is the first work to reflect Donatello's new tendencies following his stay in Rome. *It was put near the altar of the Cavalcanti Chapel. For this he made an ornament in the grotesque style, with a base of varied and intertwined work, surmounted by a quarter-circle, and with six putti; these garlanded putti have their arms round each other as if they are afraid of the height and are trying to steady themselves. Donatello's ingenuity and skill are specially apparent in the figure of the Virgin herself: frightened by the unexpected appearance of the angel she makes a modest reverence with a charming, timid movement, turning with exquisite grace towards him as he makes his salutation. The Virgin's movement and expression reveal both her humility and the gratitude appropriate to an unexpected gift, particularly a gift as great as this. Moreover, Donatello created a masterly flow of folds and curves in the draperies of the Madonna and angel, suggesting the form of the nude figures and showing how he was striving to recover the beauty of the ancients, which had been lost for so many years. He displayed such skill and facility that, in short, no one could have bettered his design, his judgement, his use of the chisel, or his execution of the work* (Vasari). The setting is elaborately classical — though the composition recalls iconographical precedents of the 14th century — and is richly decorated with lavish gilding on stone. The composition conveys a strong impression of the episode of the Annunciation: of an unlooked for gift received with serene grace. Other works of this period are inspired by an entirely different spirit.

Consider, in this context, the much-debated *Coat-of-arms of Casa Martelli* — from Palazzo Martelli in Via Larga and presently gracing the grand staircase of the palace in Via Zanetti (1799) — where the linear tension of the forms is accentuated through the pink marble of the shield, the gilded stone of the gryphon, and the grey of the male figure above.

The *Pulpit* for the exterior facade of the Cathedral in Prato, begun in 1428 and after long pauses finished ten years later, was executed by Donatello together with Pagno di Lapo and Michelozzo. Donatello was responsible for the architecture and the putti, whose joyous movements suggest a vital force that was to reach its zenith in the *Cantoria* for the Cathedral of Florence. Presently displayed in the Museum of the Opera del Duomo of Prato, it has been replaced on the outside with a copy.

In 1431 the Opera del Duomo commissioned Luca della Robbia to erect a large marble *Cantoria*, or singers' gallery, over the entrance to the north sacristy in the Cathedral. In 1433, two years after Luca della Robbia began his work, Donatello was commissioned to design another *Cantoria* to be placed over the south sacristy where it would form a counterpart to the one

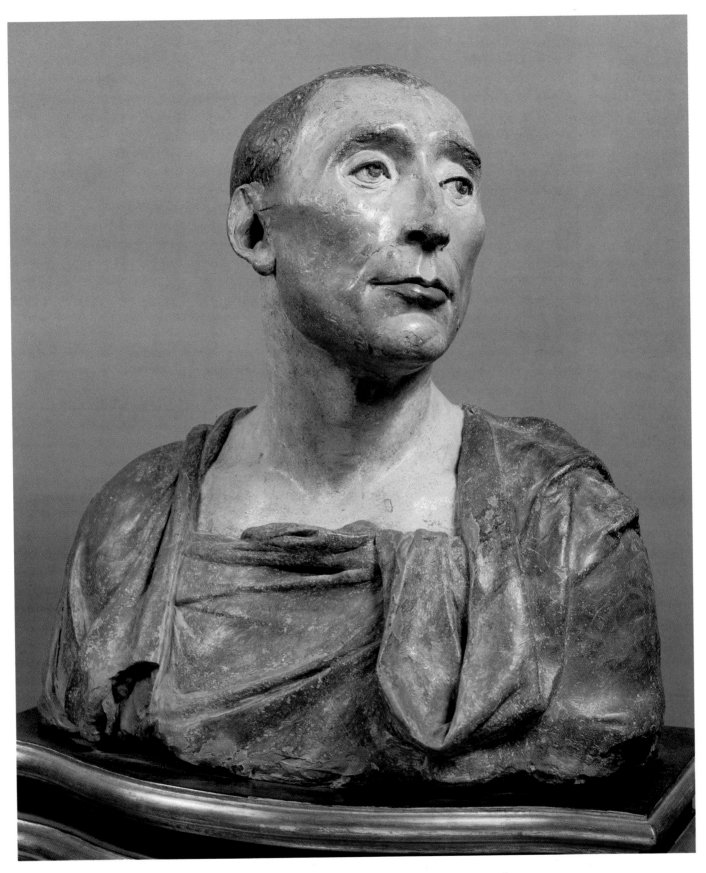

46. Bust of Niccolò da Uzzano (after restoration)
h. 46 cm
Florence, National Museum of the Bargello

made by Della Robbia. Both were completed in 1439. The two works are no longer in their original position but can be seen in the Museum of the Opera del Duomo. On the occasion of the marriage of Ferdinando de' Medici with Violante of Bavaria in 1688 the two structures were found to be too small to accommodate all the singers, and they were replaced by wooden balconies. Later, stone ones were substituted and are still in place today. Not until 1891 were the two *cantorie* reassembled in the Museum of the Opera del Duomo, after having been kept dismantled at the Bargello for some time. *The contract is dated 14 November and it was agreed to pay Donatello between forty and fifty florins for each piece, according to the quality of the work. The sums allocated, which amounted to six hundred florins, go from 19 November 1433 to 5 February 1440. In the August of '36 Donatello was supplied with the marble 'pro faciend corniciem perghami', in the October of '38 it is said that the pulpit 'est prope finitum', and in the March of the following year the sculptor was allocated seven florins 'per certo marmo disse avere chomprato per metere nel perghamo ch'egli à fatto'... The whole work, 'habito colloquio cum pluribus intelligentibus tam intagli quam giettii' was estimated many years after its completion, in 1446, at eight hundred and ninety-six florins, and since Donatello was still owed some of this amount, the Opera promised Cosimo de' Medici that it would pay off its debt within six months from the day in which the sculptor cast the door of the old Sacristy* (Colasanti).

In this work, where *the figures are only outlined and not finished* and *appear thus from ground level* (anonymous author of the Magliabechi manuscripts), Donatello again creates something new. The austerity and sternness which emanated from his youthful statues have vanished, and in their place is a vivacious, almost orgiastic movement. Five consoles support five pairs of corresponding columns, and these in turn are surmounted by a pediment decorated with acanthus and other ornamental devices. Behind the column is a frieze of running putti caught in a wide variety of movements. They run, leap and dance against a glittering background of Cosmatesque mosaic — a symbol of the infinite which cannot be grasped.

With the putti of the *Cantoria* of the Cathedral and those of the *Pulpit* in Prato we should also place the bronze statuette of the Bargello, known as *Atys*. Mentioned by Vasari in 1568 as being in the house of *Giovanbattista d'Agnol Doni*, a Florentine nobleman, as *a bronze Mercury by Donatello, standing three feet high in full relief and clothed in a curious fashion*, which is ex-

47. *The David of Casa Martelli*
h. 162 cm
Washington, National Gallery of Art

48. *Annunciation*
218 x 168 cm
Florence, Church of Santa Croce

36

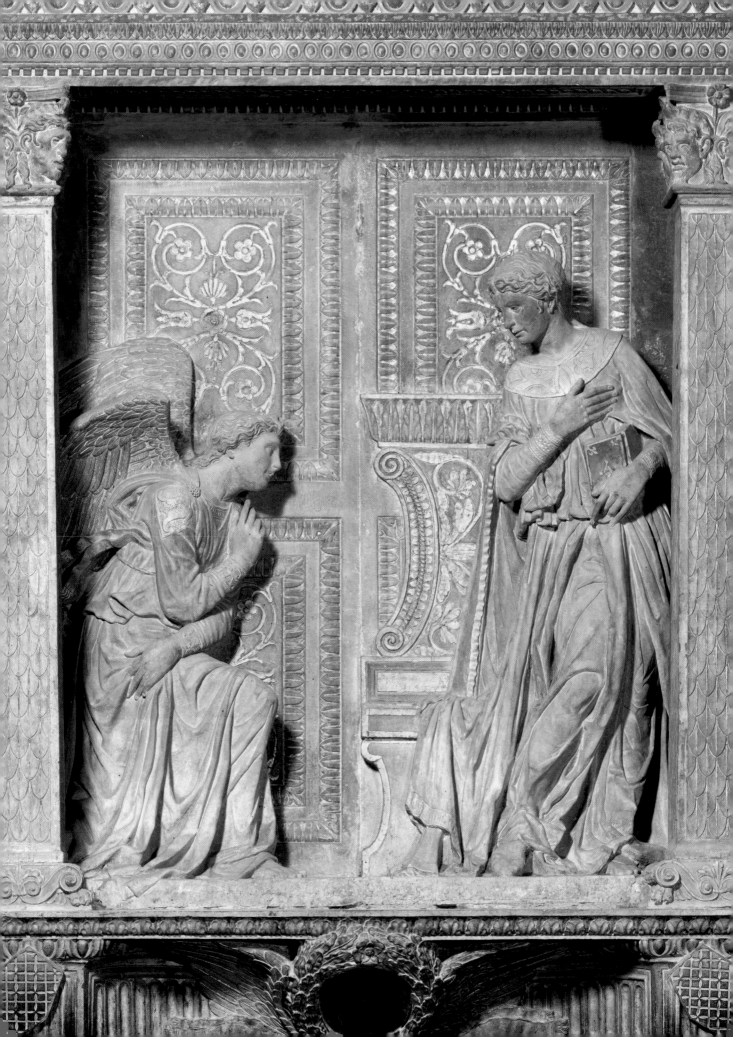

tremely attractive, it was immediately and very favourably compared with the most famous works in the same collection (like Raphael's *Doni Portraits*), *no less outstanding than the other works which adorned that beautiful house*. In 1677 Cinelli shared Vasari's judgement, though he believed the *bronze statue antique* and of difficult identification (*regarded as a Perseus by some, by others a Mercury*). The *Idol* (as it was then called) was put up for sale by Pietro Bono Doni in 1778 and bought by the then director of the Gallery, Giuseppe Pelli Bencivenni, as an Etruscan idol of outstanding workmanship, according to the indications of various experts like the antique-dealer of the Uffizi, Luigi Lanzi, Ennio Quirino Visconti, head of the Vatican Museum, and Maffei, trustee of the famous Albani collection. But the following year Lanzi opted for a modern dating and for the Vasarian attribution to Donatello. Having been labelled, therefore, with various names — Mercury, Perseus, Pantheus, young Hercules, Atys beloved of the goddess Cybele, Cupid — the *Amor-Atys* of the Bargello was conceived in the same spirit as the putti of the *Cantoria*, and is therefore datable prior to 1440. Related to the *Atys* of the Bargello are the two *Candelabra Angels* of the Musée Jacquemart-André in Paris. The controversy surrounding their authorship — disputed between Donatello and Luca della Robbia — is still open. Darr's hypothesis, that the two artists collaborated together on the execution of the aforementioned bronzes for one of the *Cantorie*, is also plausible. There is the same well-rounded body animated by a strongly pagan vitality and an ambiguous intellectualism which almost seems to foreshadow the Mannerists of a century later.

Donatello's only "pictorial" work in the period 1434-1438 is the *Coronation of the Virgin*, a stained-glass window in the drum of the Cathedral dome. It is not easy to give an opinion on this work owing to its poor state of preservation. With much of the shading of the faces fallen away, only the elegant outline bears witness to the high interpretative qualities of the designer.

From 1428 (some say 1434) to about 1443 Donatello was at work on the sculptural decoration of the *Old Sacristy* of San Lorenzo, built by Brunelleschi between 1418 and 1428. This decoration, carried out with bronzes and polychrome stuccos (the first example of its kind in Florentine sculpture of the Quattrocento) comprises *two arched reliefs* above the bronze doors of the altar wall, one showing St Cosmas and St Damian, the other St Stephen and St Lawrence — both pairs in attitudes of concerned disputation — *eight roundels* in polychrome stucco with the four

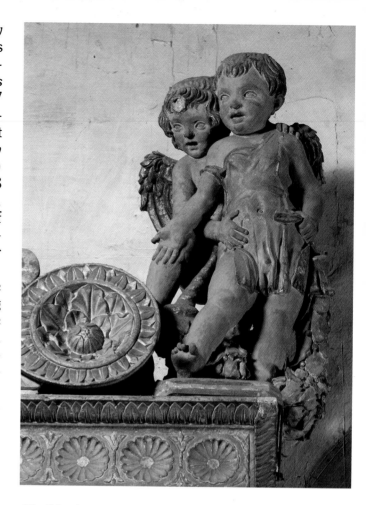

49, 50. *Annunciation, details*
Florence, Church of Santa Croce

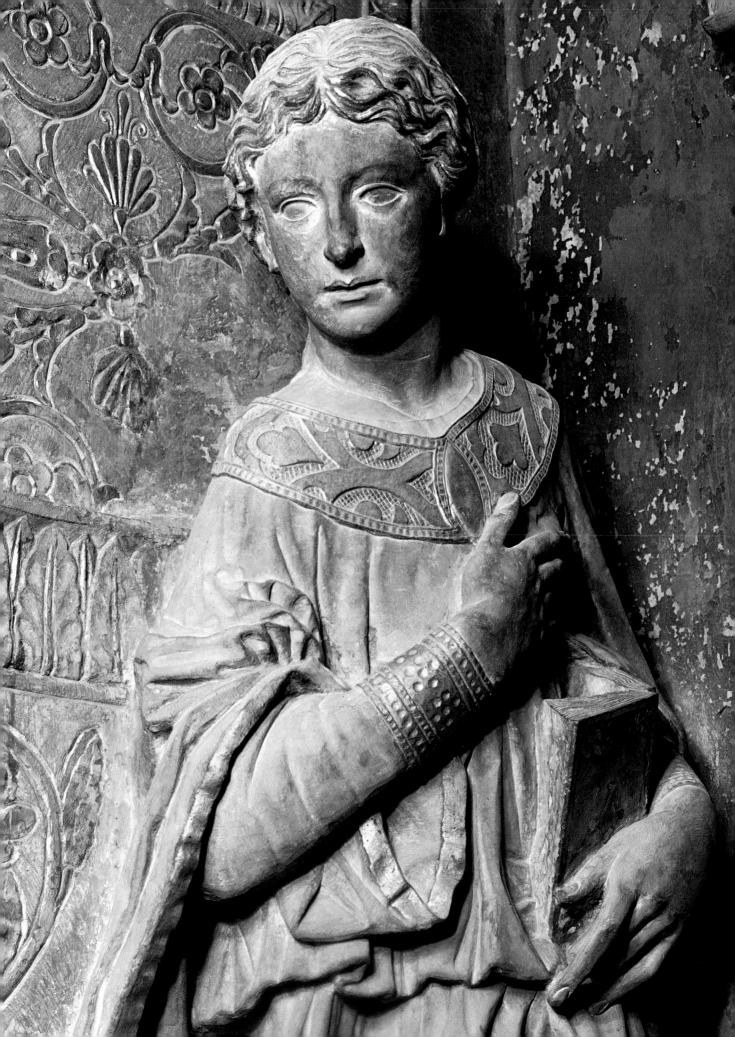

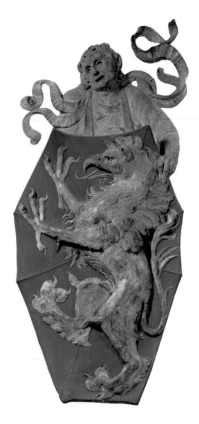

51. Coat-of-arms of
Casa Martelli
Florence, Palazzo
Martelli

52-54. The Pulpit of
Prato Cathedral
73.5 x 79 cm each
relief
Prato, now in the
Museum of the
Opera del Duomo

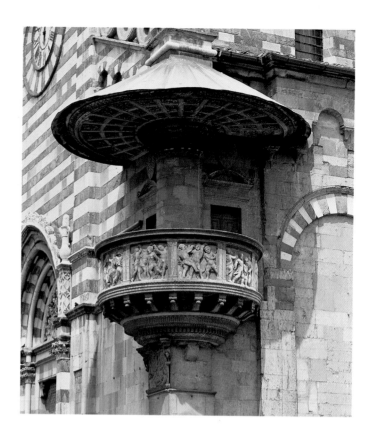

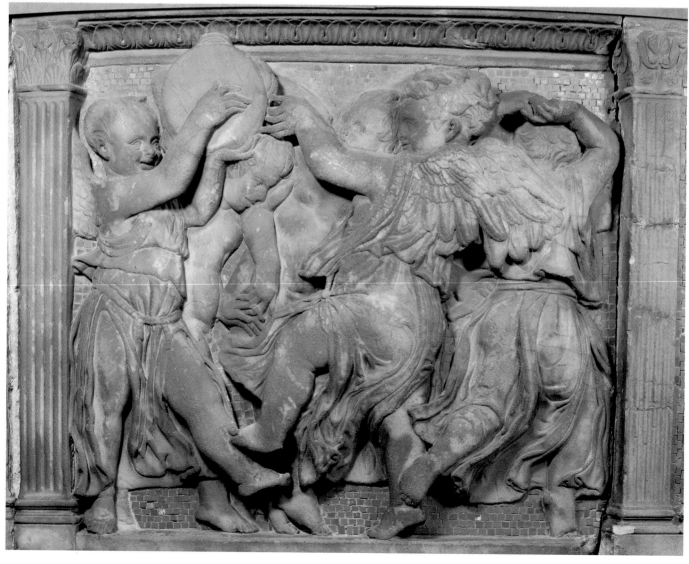

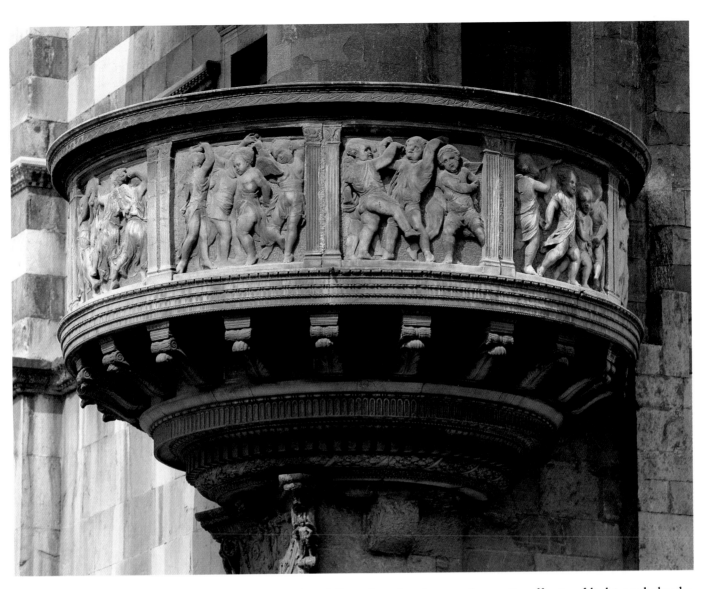

Evangelists and four episodes from the life of St John (*St John on Patmos*, the *Resurrection of Drusiana*, the *Martyrdom* and the *Ascension of St John*), and *two bronze doors* divided into ten compartments each with the Apostles and Martyrs. The colour decoration of the austerely architectural sacristy pleased neither Brunelleschi nor his contemporaries, and once again, as at the time of the *Crucifixion* in Santa Croce, they were at a loss to understand Donatello's restless search for ever new forms of artistic expression.

Chronologically close together and perhaps the first works executed for the sacristy are the two arched reliefs in polychrome terracotta above the doors, in which, especially between St Stephen and St Lawrence, the dramatic force of the disputation reaches a disturbing pitch. The pliability of the material, terracotta and stucco, was in itself suitable for creating a charged and uneasy atmosphere. In the pendentive roundels the harshness of the scheme is sharpened by a daring experiment in perspective which creates large spaces in which human figures and architectural

details take on dramatic effects of light and shade. The other four roundels show the Evangelists realistically robed and seated at their desks. They are three-quarter length and in profile, and in the bold perspective and foreshortening of the figures Donatello repeats his dynamic concept of representation. The culminating point of this conception was reached in the last work he executed for the sacristy, the two bronze doors, whose motivating inspiration is so different from that of Ghiberti, then working on his second Baptistery door, the *Door of Paradise*. Forty Apostles and Doctors of the Church are spread over the twenty panels. They meet, they engage in discussion, and in the heat of their arguments they appear to detain and pursue one another. Every scene is animated by an acute dynamic tension, and for the first time in the Renaissance, space is shown as infinite. *In this way, Donatello laid the foundations of modern impressionistic sculpture, but he also broke dramatically with the aesthetic canons of Brunelleschi, so that to the great architect and the intellectual milieu of which he was the leader,*

41

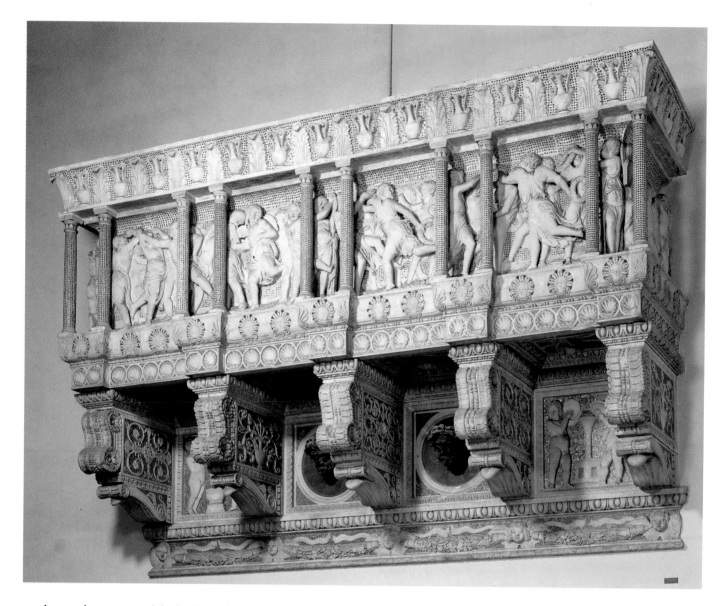

such works seemed little less than a provocation (Paolucci). The recent restoration of 1984-86, carried out by the Soprintendenza ai Beni Architettonici and the Opificio delle Pietre Dure, has revealed the close relationship between decoration and architecture, both of which were incorporated in the original plan.

In 1443 Donatello went to Padua to work on the bronze *Crucifix* intended for the altar in the centre of the choir of Il Santo (the Church of St Anthony of Padua). We know from a contemporary document that it was being finished and polished in 1445 but that it was completed only in 1449, when it was placed in the middle of the church. It was not therefore conceived as part of the group called the *Altare del Santo*, which Donatello executed about 1447-50, composed altogether of twenty-nine pieces of sculpture. Seven free-standing bronze statues (*Madonna Enthroned with Child, St Francis, St Anthony, St Daniel, St Justina, St Louis, St Prosdocimo*), four bas-reliefs in bronze with the miracles of St Antho-

ny (*Miracle of the Ass, Miracle of the New-born Child, Miracle of the Repentant Son, Miracle of the Avaricious Man's Heart*); four bas-reliefs in bronze with the symbols of the *Evangelists*, another bas-relief of the *Dead Christ supported by two putti*, twelve reliefs with *Musician Angels*, and finally a relief in Nanto stone depicting the *Entombment*. Unfortunately today we can have no idea of the true architectural arrangement of all this material. In fact at the end of the 16th century Donatello's altar was taken to pieces to make way for another by Gerolamo Campagna and Cesare Franco, which included Donatello's *Crucifix*. Finally in 1895 the present altar was designed as a reconstruction of Donatello's altar, though it is an arbitrary one only, and the introduction of the bronze *Crucifix* is a falsification in 19th-century taste. Modern critics have repeatedly sought to arrive at a reconstruction which most closely resembles Donatello's ideal, and perhaps the most plausible is the one by Fiocco. Fundamentally it corresponds to the description, however incomplete,

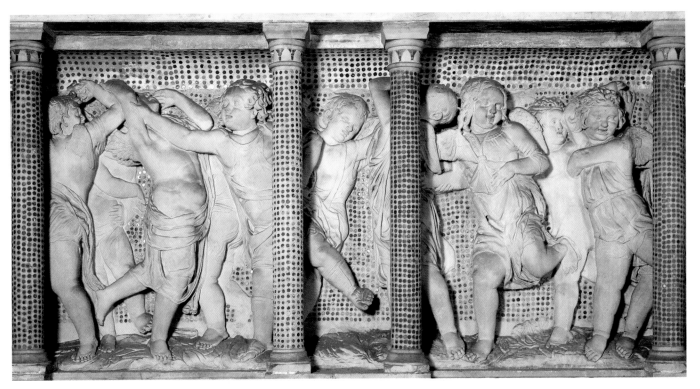

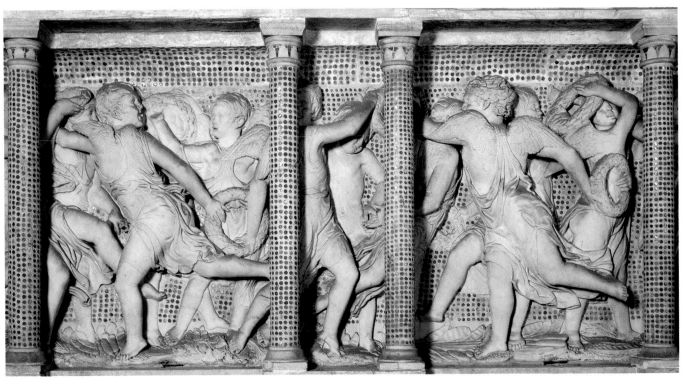

55-57. The 'Cantoria'
348 x 570 cm
Florence, Museum of the Opera del Duomo

58, 59. Atys
h. 104 cm
Florence, National Museum of the Bargello

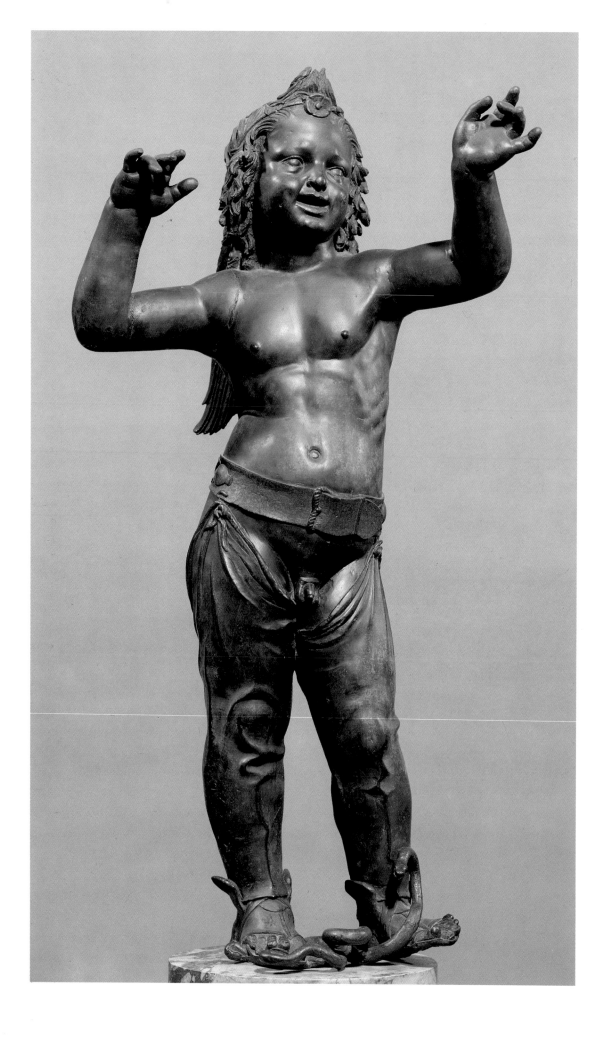

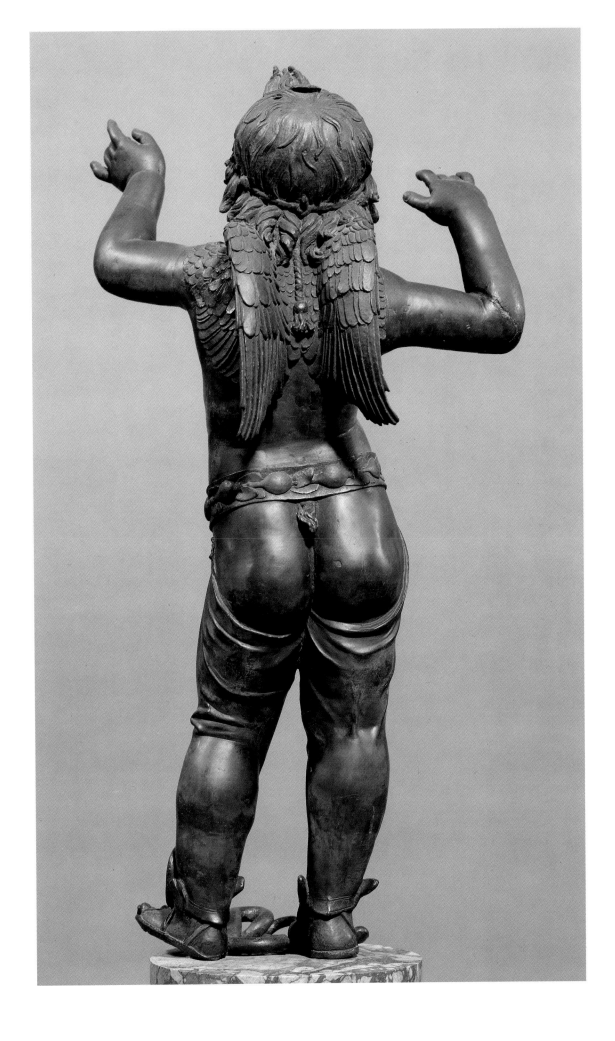

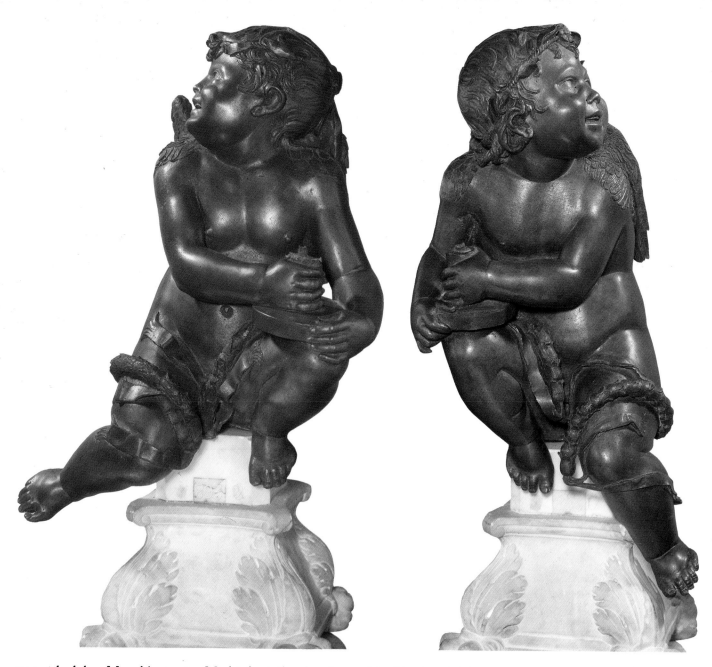

provided by Marc'Antonio Michiel at the beginning of the 16th century. *In the church of the Saint above the high altar, the four bronze figures entirely in the round, grouped around Our Lady, Our Lady herself, and beneath the aforesaid figures, in the predella, two bronze narrative bas-reliefs in front and two behind. And the four Evangelists at the corners, two in front and two behind of bronze and in bas-relief, but in half length, and behind the altar beneath the predella the dead Christ with other figures around and two figures to the right and two to the left, also in bas-relief but in marble, by the hand of Donatello.*

This sculptural group, rich with polychrome effects due to the use of coloured marbles, of gold, silver and bronze decorations, must have offered a remarkably brilliant spectacle. The statues of the Church of St Anthony mark another step in the

60, 61. Candelabra Angels
Paris, Musée Jacquemart-André

62. Stained-glass window showing the Coronation of the Virgin
diam. 380 cm
Florence, Cathedral of Santa Maria del Fiore

artist's evolution, and it is obvious that the free-standing treatment of the figures allowed an even wider use of expressive effects. In the *Miracles* series Donatello adopted flattened relief on a roughened surface which served to break up the light and diffuse it, thus achieving a luminous atmosphere in which the incorporeal images appear to float. Never until now had architecture played

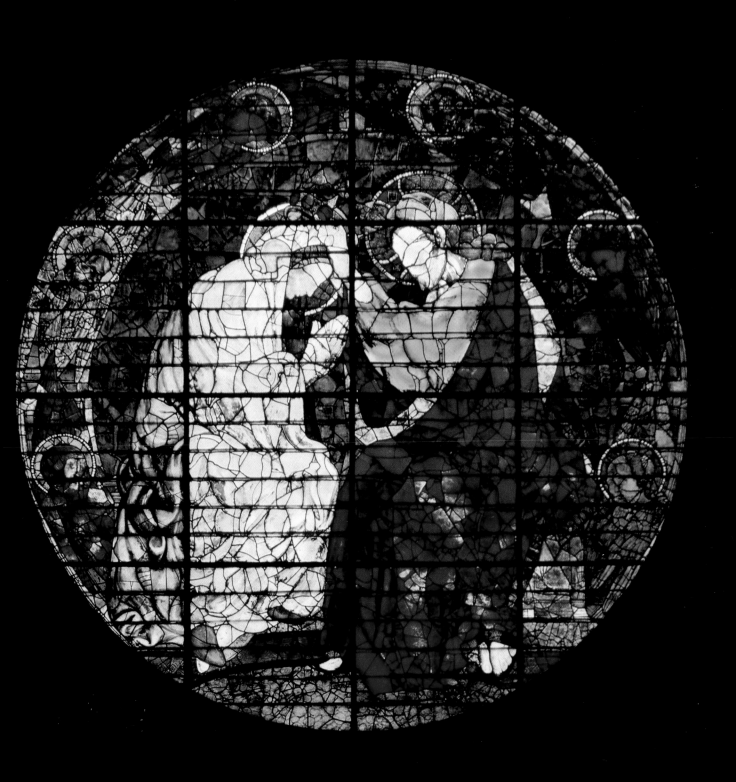

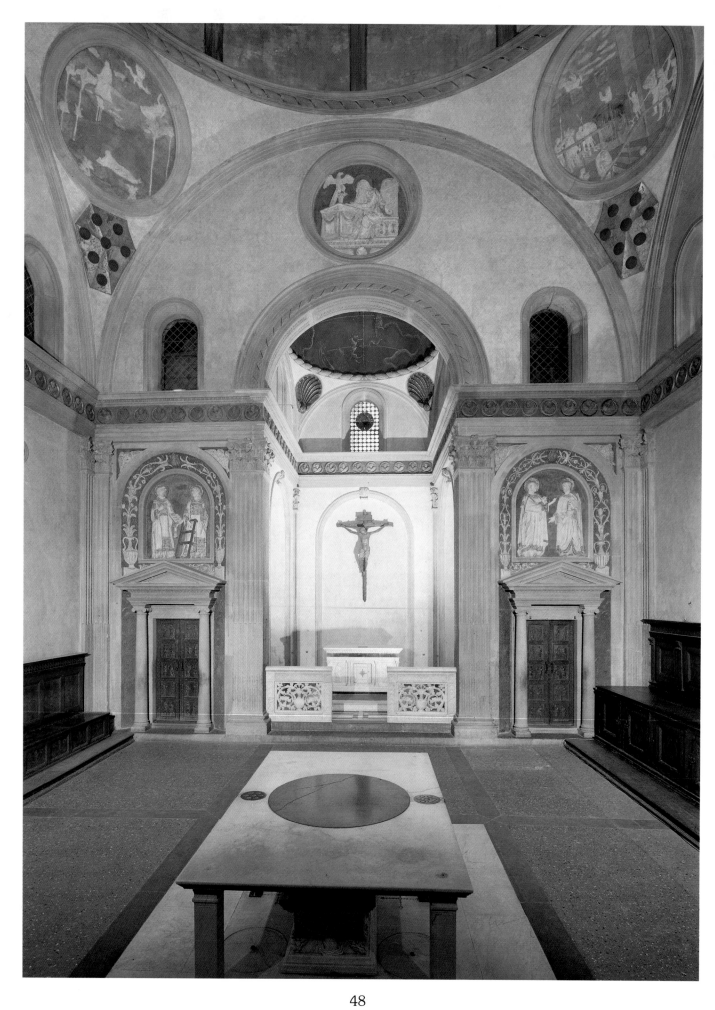

63. Brunelleschi and Donatello
The Old Sacristy (after restoration)
Florence, Church of San Lorenzo

64. Architectural detail showing the putti of the
trabeation of the Old Sacristy

65, 66. The bronze doors of the Old Sacristy with
the representation of the Martyrs and Apostles

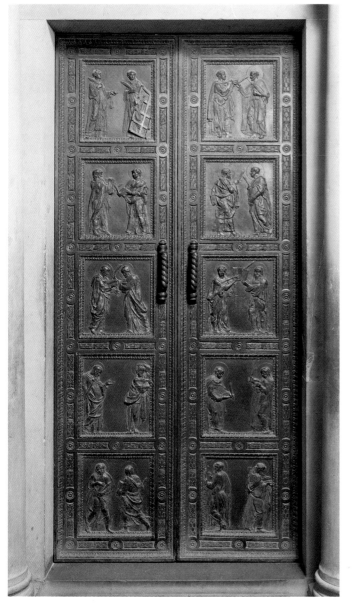

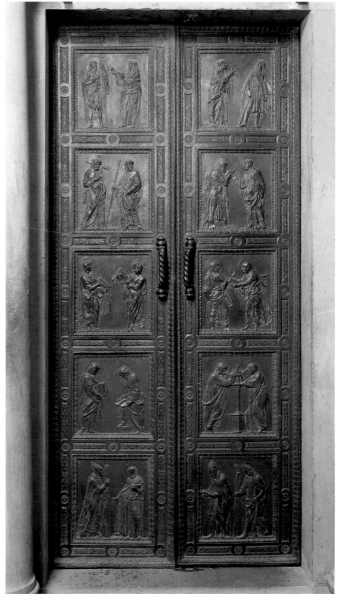

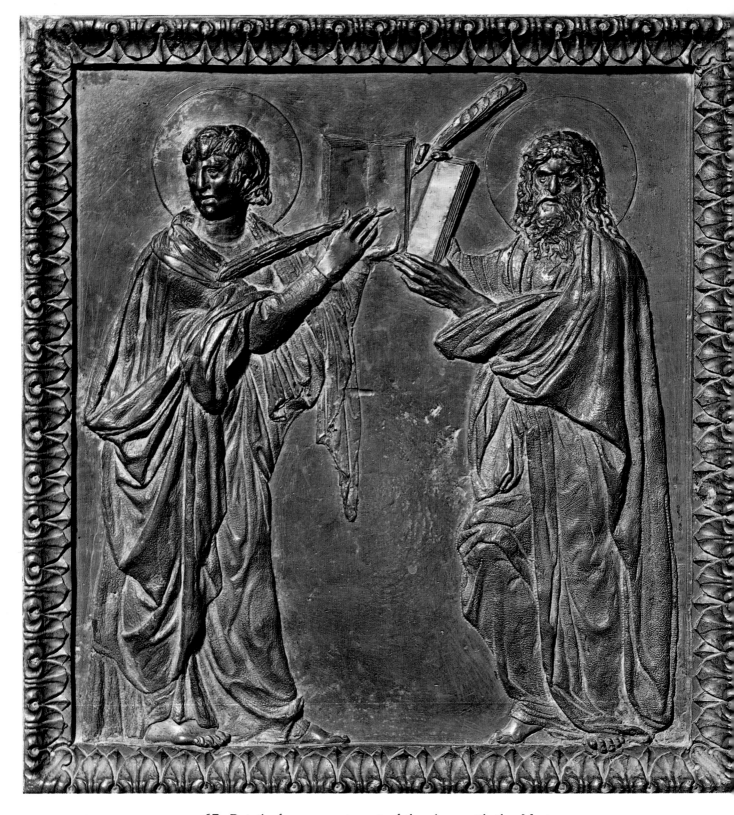

67. Detail of a compartment of the door with the Martyrs
31 x 29 cm
Florence, Old Sacristy of San Lorenzo

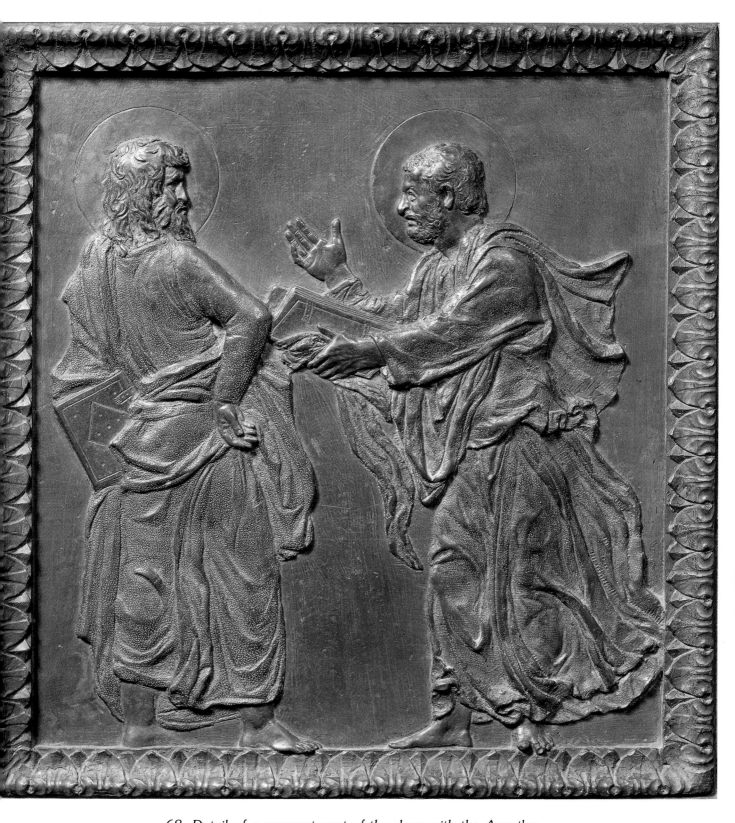

68. Detail of a compartment of the door with the Apostles
30 x 29 cm
Florence, Old Sacristy of San Lorenzo

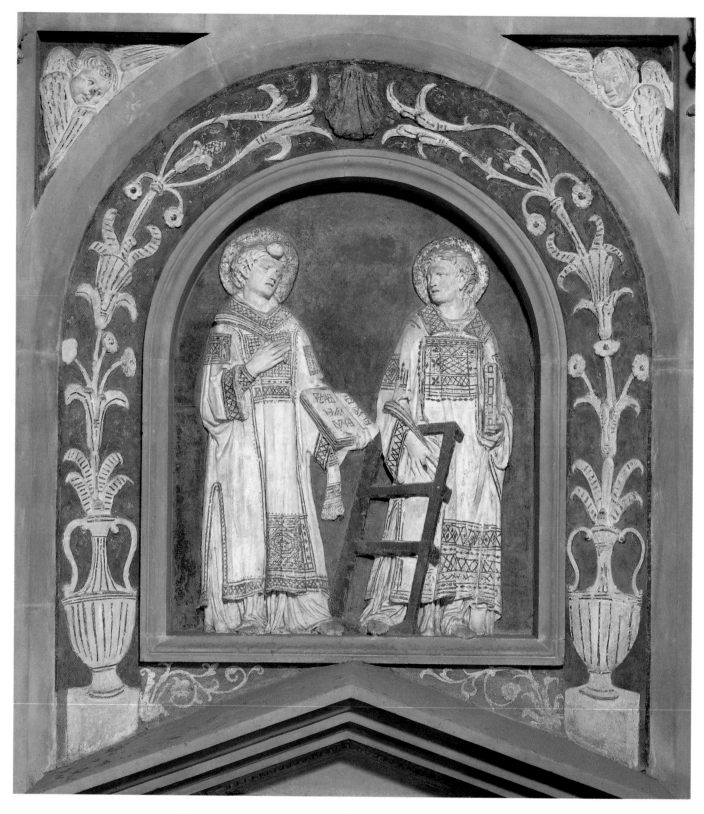

69. Arched relief showing St Stephen and St Lawrence
c. 215 x 180 cm
Florence, Old Sacristy of San Lorenzo

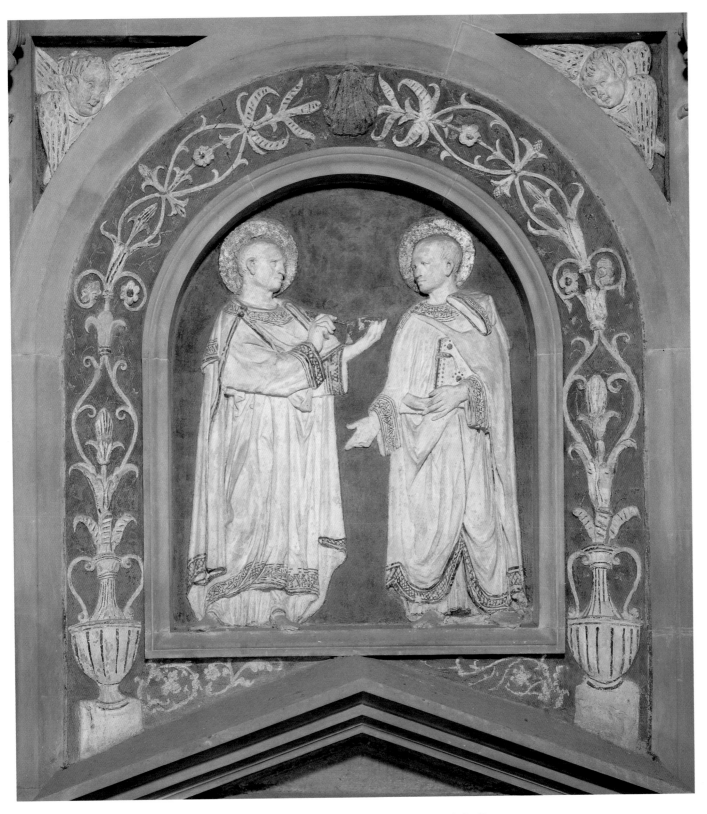

70. Arched relief showing St Cosmas and St Damian
c. 215 x 180 cm
Florence, Old Sacristy of San Lorenzo

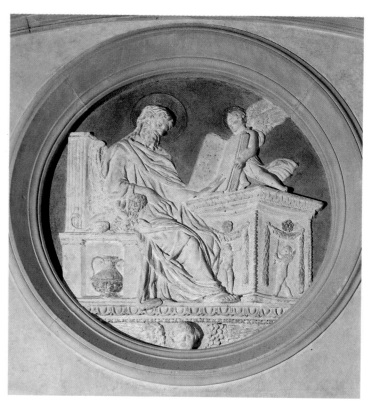
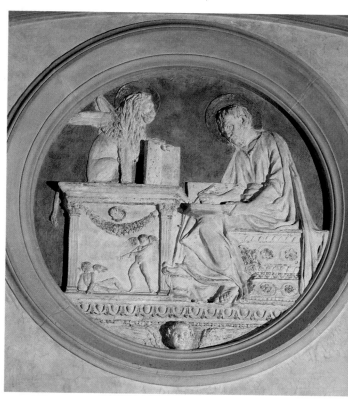
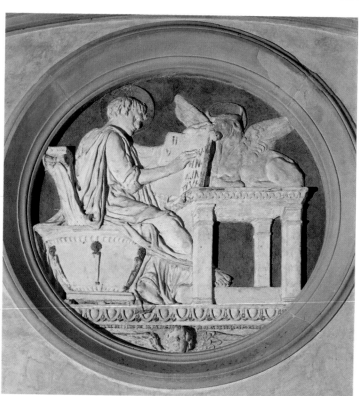
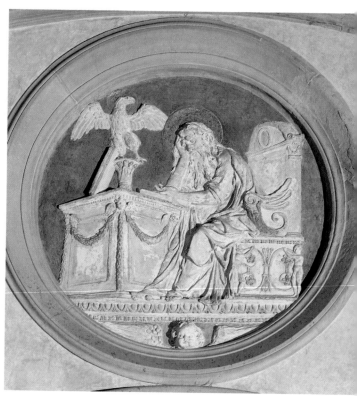

71-74. Roundels with the Evangelists Matthew, Mark, Luke and John
diam. 215 cm
Florence, Old Sacristy of San Lorenzo

54

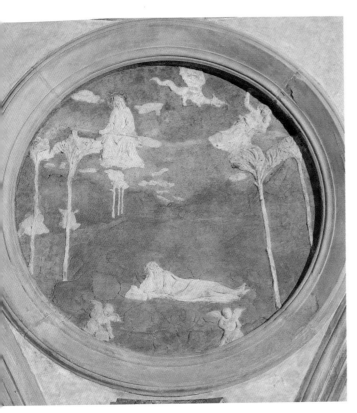

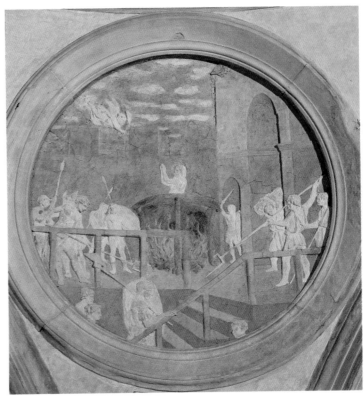

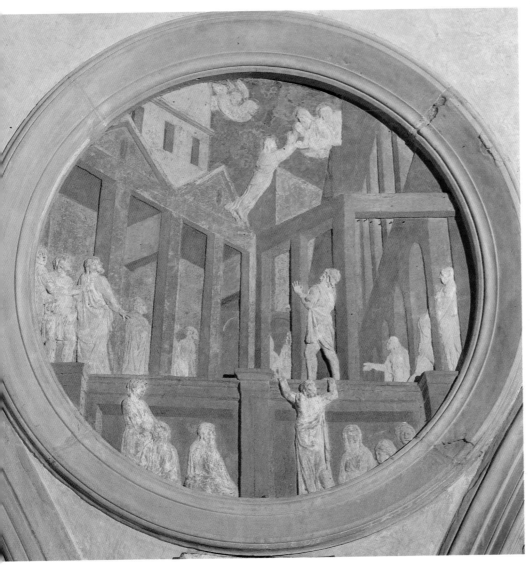

75-77. Roundels with episodes from the life of St John:
St John on Patmos, the Martyrdom and the Ascension of St John
diam. 215 cm
Florence, Old Sacristy of San Lorenzo

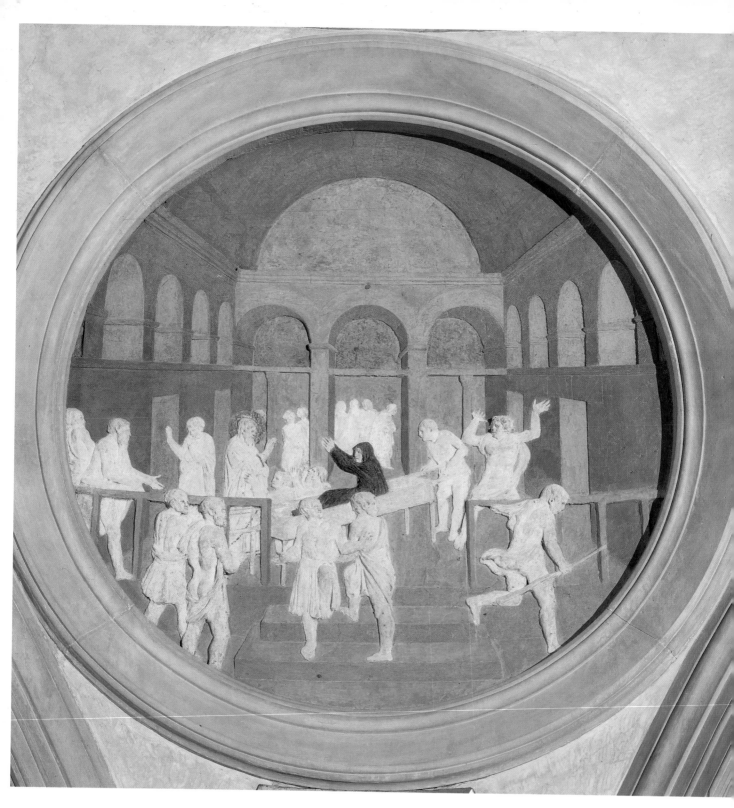

such a prominent part in narrative relief scenes. In the *Miracles* it is the rhythm of the architecture that unites the jostling crowd and is felt to be the chief protagonist. The centre-piece of the altar is the group of the *Madonna and Child*. The Madonna is represented as an arcane priestess rising from between the faces of two smiling sphinxes at the base of her throne. It is probable that for this unusual representation of the Virgin, so oriental in feeling, neither seated nor standing but

78. Roundel with the Resurrection of Drusiana
diam. 215 cm
Florence, Old Sacristy of San Lorenzo

79. Crucifix
180 x 166 cm
Padua, Basilica of St Anthony

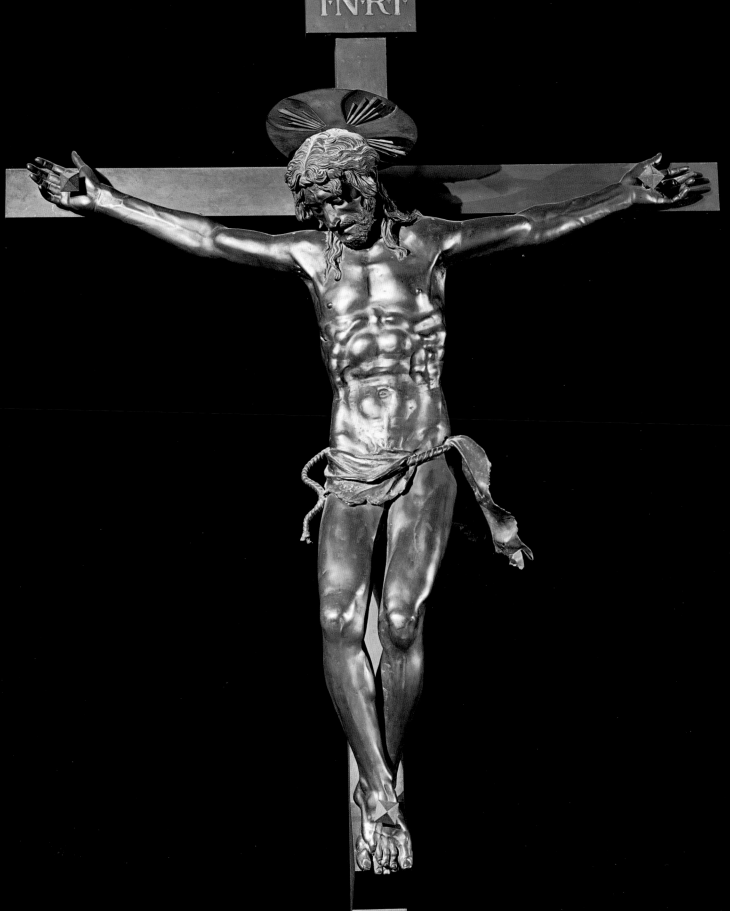

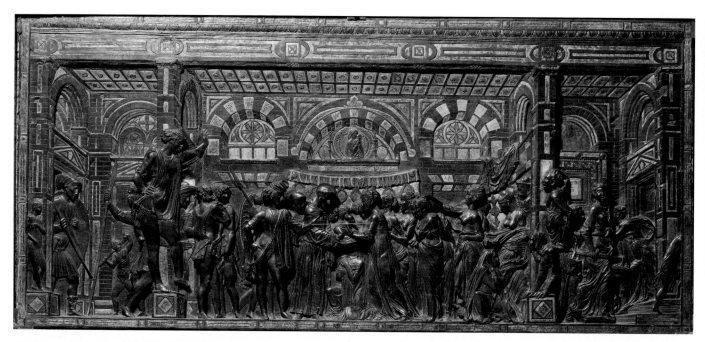

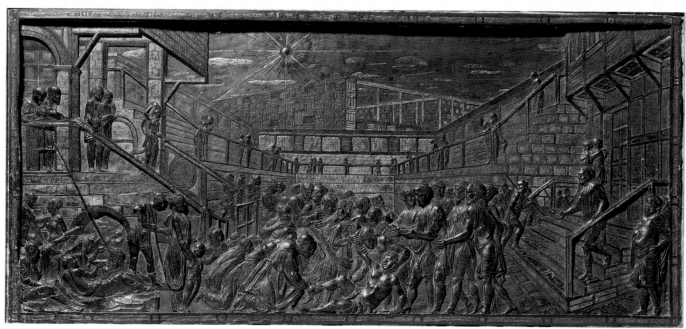

80, 82. Miracle of the New-born Child
57 x 123 cm
Padua, Basilica of St Anthony

81. Miracle of the Repentant Son
57 x 123 cm
Padua, Basilica of St Anthony

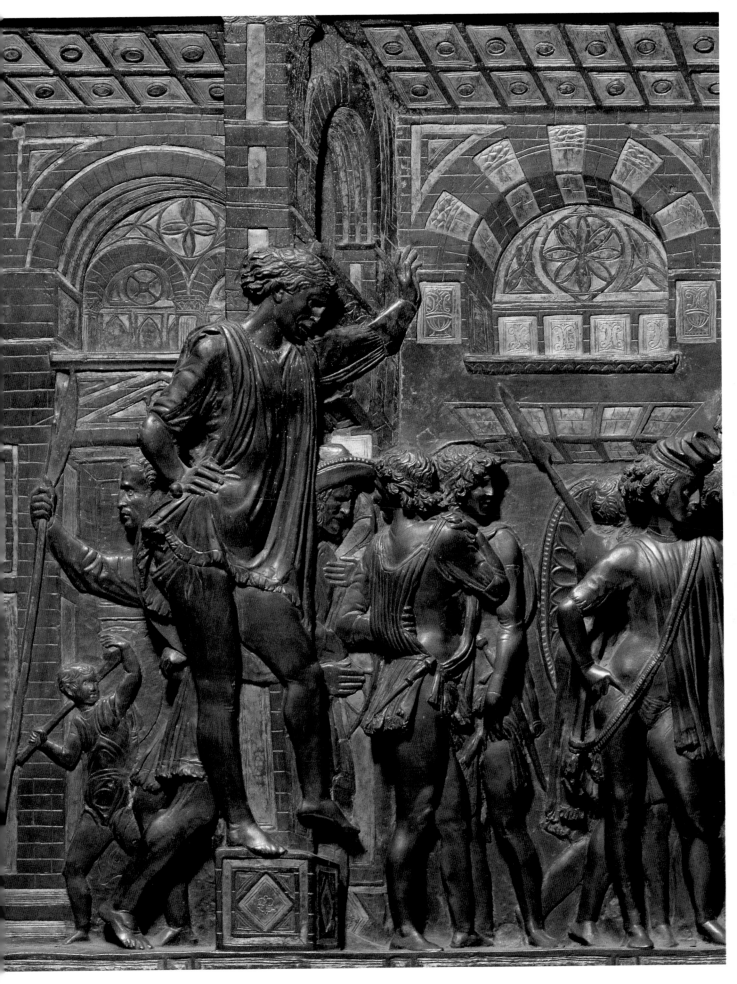

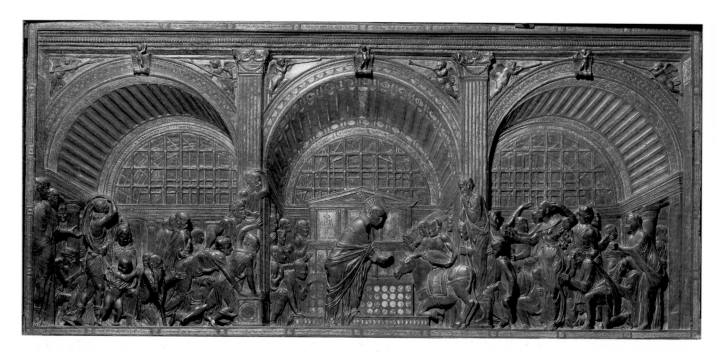

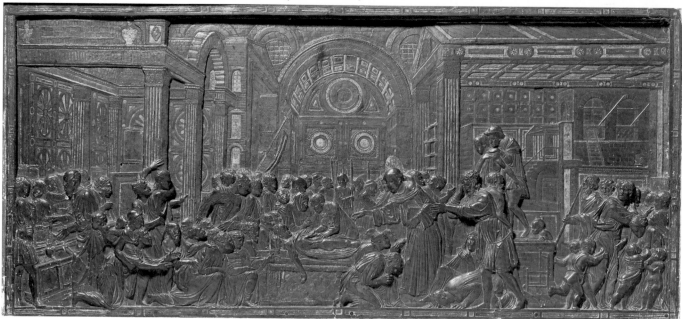

83, 85. Miracle of the Ass
57 x 123 cm
Padua, Basilica of St Anthony

84. Miracle of the Avaricious Man's Heart
57 x 123 cm
Padua, Basilica of St Anthony

86. Entombment
139 x 188 cm
Padua, Basilica of St Anthony

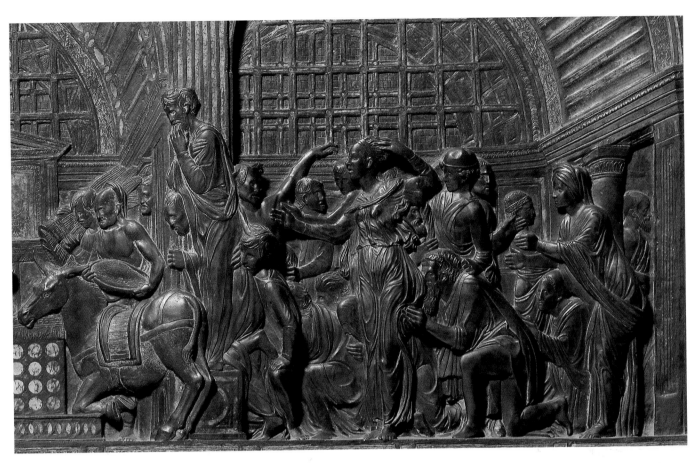

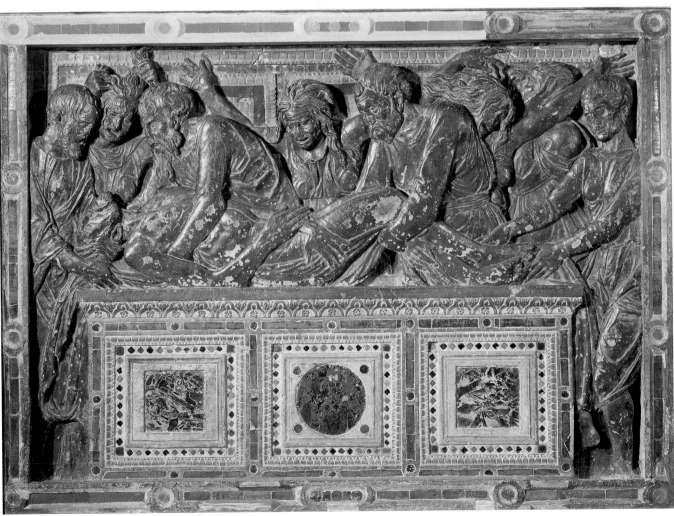

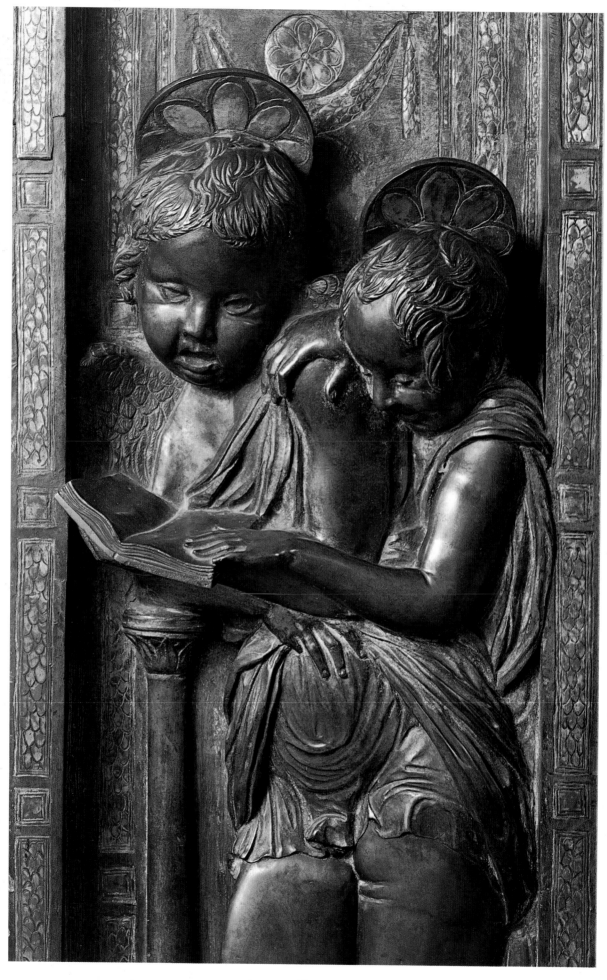

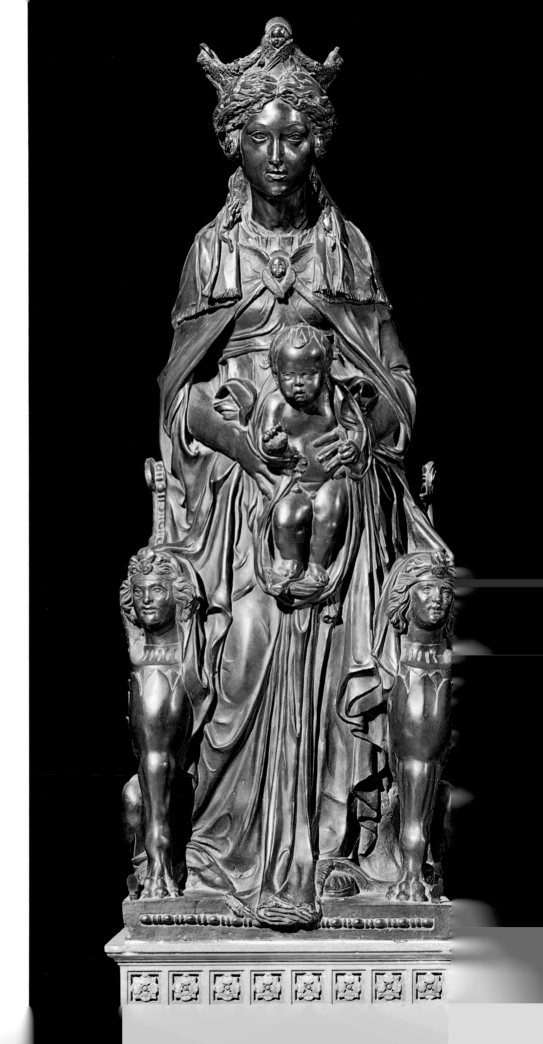

87. Musician Angels
58 x 21 cm
Padua, Basilica of St
Anthony

88. Madonna and Child
h. 160 cm
Padua, Basilica of St
Anthony

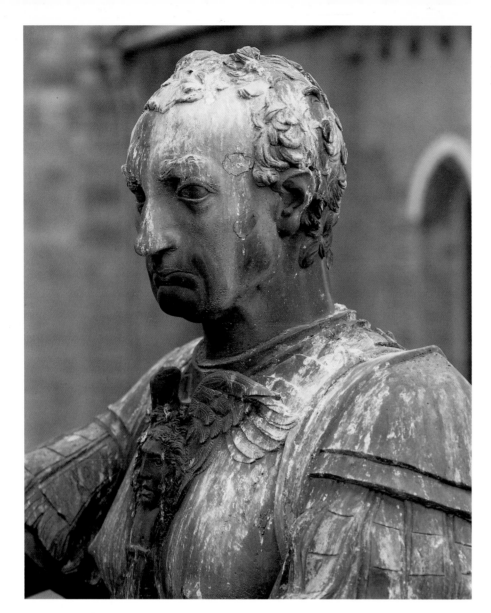

caught in the moment of rising, Donatello was inspired by some Byzantine icon or even a piece of Etruscan statuary.

While he was working on the High Altar of St Anthony, Donatello also executed the *Equestrian Statue of Gattamelata.* This was set up in front of the church in a space then used as a cemetery. Both horse and rider — inspired by the *Statue of Marcus Aurelius* in Rome, or the Greek horses atop the Venetian Church of St Mark's — were a complete unit destined to become the prototype of many subsequent equestrian monuments. According to Planiscig, the uncovered head of Gattamelata seems like a physiognomical study. But in fact the victorious captain's face is the type of the perfect condottiero — the hero-conqueror then being celebrated by Renaissance literature. *Indeed, Donatello proved himself such a master in the proportions and excellence of this huge cast that he challenges comparison with any of the ancient craftsmen in expressing movement, in design, skill, diligence, and proportion. The work astounded everyone who saw it then and it continues to astound anyone who sees it today* (Vasari).

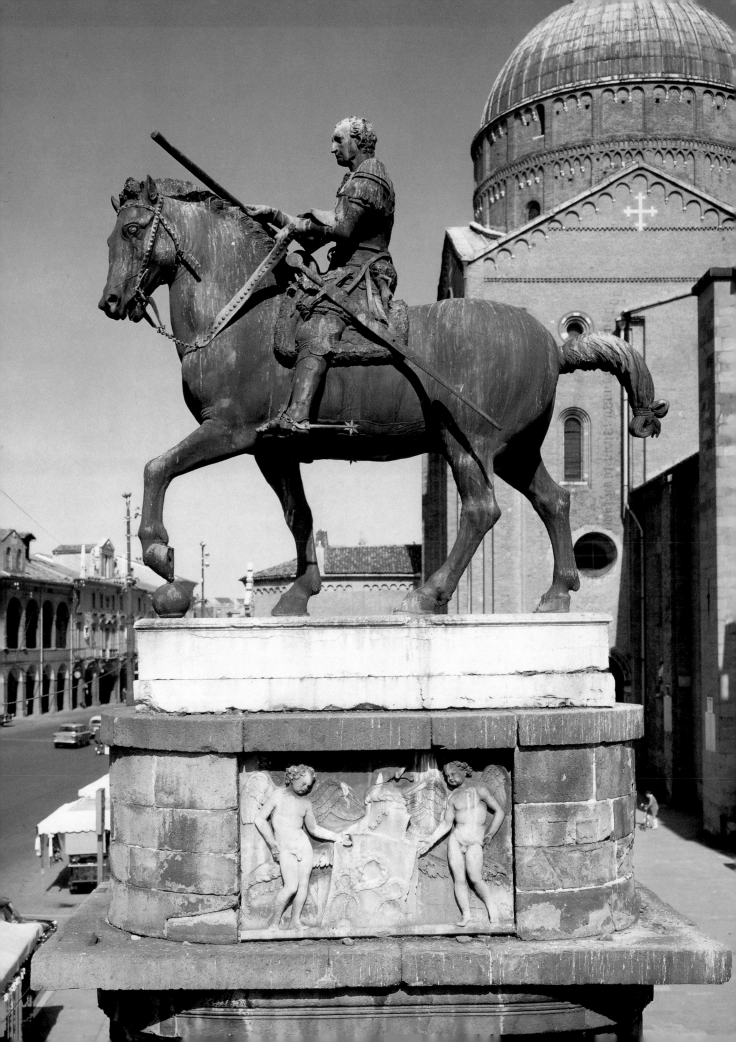

The Last Years

Donatello returned to Florence in 1454. Unlike the artists of northern Italy, such as Mantegna and Tura, the artistic world of Florence, dominated by the refined spirit of Rossellino and Mino da Fiesole, by the elegiac grace of Desiderio da Settignano, and by the classical line of Luca della Robbia, failed to understand the victories that Donatello achieved in the field of sculpture. Many years were to pass until in the Mannerist culture of the mid-16th century his qualities became fully accepted and highly esteemed. Side by side with the Florentine works based on Leon Battista Alberti's principles of "grazia", Donatello, by now ageing, went his own way, continuing in his search though remaining faithful to the principle themes of his youthful experimentation: the manifold viewpoints; the whittling down of form; the increasingly confident conquest of space through the rounding of the figures. In these last ten years of his life (he died in 1466) Donatello produced the group of *Judith and Holofernes*, the *St John the Baptist* in Siena, the *Mary Magdalen* of the Baptistery in Florence, the *St John the Baptist* of the Church of Santa Maria Gloriosa dei Frari in Venice, the *Crucifixion* of the Bargello, and finally, two *Pulpits* for the Basilica of San Lorenzo in Florence.

The difficult bronze sculpture of *Judith and Holofernes* was made by Donatello *for the Signoria of Florence... a casting in metal, showing Judith cutting off the head of Holofernes, which was placed in the piazza under one of the arches of their loggia. This is an excellent and accomplished work in which, by the appearance of Judith and the simplicity of her garments, Donatello reveals to the onlooker the woman's hidden courage and the inner strength she derives from God. Similarly, one can see the effect of wine and sleep in the expression of Holofernes and the presence of death in his limbs which, as his soul has departed, are cold and limp. Donatello worked so well that the casting emerged very delicate and beautiful, and then he finished it so carefully that it is a marvel to see. The base, which is a simply designed granite baluster, is also pleasing to the eye and very graceful. Donatello was so satisfied with the results that he decided, for the first time, to put his name on one of his works; and it is seen in these words: DONATELLI OPUS* (Vasari). Donatello was commissioned to do the sculpture by Cosimo de' Medici between 1455 and 1460 as the decoration for a fountain in the garden of Palazzo Medici-Riccardi. In 1495 it was placed at the side of the main door of Palazzo della Signoria as the symbol of the liberty of the Florentine people; from here it was moved to the first courtyard, subsequently transferred to the Loggia dei Lanzi, and in 1919 again placed on the raised platform in front of Palazzo della Signoria. In 1980 it was removed for restoration and replaced by a bronze copy (1988). Designed to stand freely in space and to appear alive from every possible point of vision, it precedes the figure of *St John the Baptist* of Siena Cathedral.

The bronze statue of *St John the Baptist*, documented and dated 1457 on its wooden base, carries on the incessant pulsing that animates the *Judith* and in its expression of pain and grief comes very close to the wooden sculpture of *Mary Magdalen* in the Baptistery of Florence. The restoration of the latter, which was necessary after the flood of 1966, has brought out the original polychrome, accentuating the ascetic physicality of the sculpture, *a finely executed and impressive work. She is portrayed as wasted away by her fastings and abstinence, and Donatello's expert knowledge of anatomy is demonstrated by the perfect accuracy of every part of the figure* (Vasari).

The bronze *Chellini Madonna*, whose back is an exact reverse image of the front, can be dated before August 1456. This roundel, which appeared on the antique market in 1975 and was purchased by the London Victoria and Albert Museum, corresponds to the roundel donated by Donatello to his physician Giovanni Chellini Samminiati, and described in detail in the latter's *Libro debitori creditori e ricordanze*. He writes: *I recall that on 27 August 1456, having treated Donato, called Donatello, a singular and prestigious master of making figures in bronze, wood and fired clay, who had made that large figure which is in a chapel above the door of Santa Reparata facing the Servites monastery, and had begun making another one nine braccia high, he, out of his kindness and because of the medication I had been administering, gave me a roundel as big as a tray in which was carved the Virgin Mary with the Child in her arms and two angels at her sides, all made of bronze and hollowed out on the reverse side in order that molten glass could be poured into the impression and the said figures be reproduced from the other side.* When presenting the piece at the 'Donatello e i suoi' exhibition, Radcliffe interestingly pointed out that *the back of the mould is interpreted by Pope-Hennessy as*

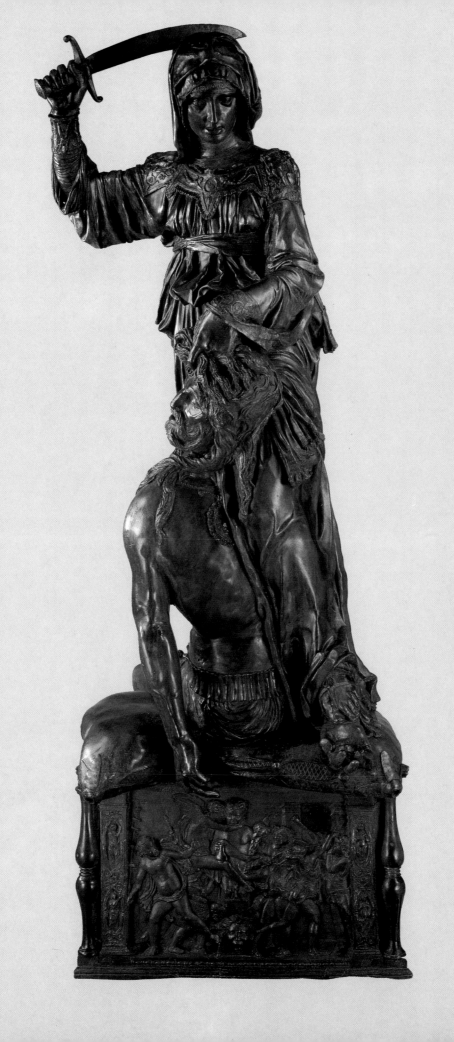

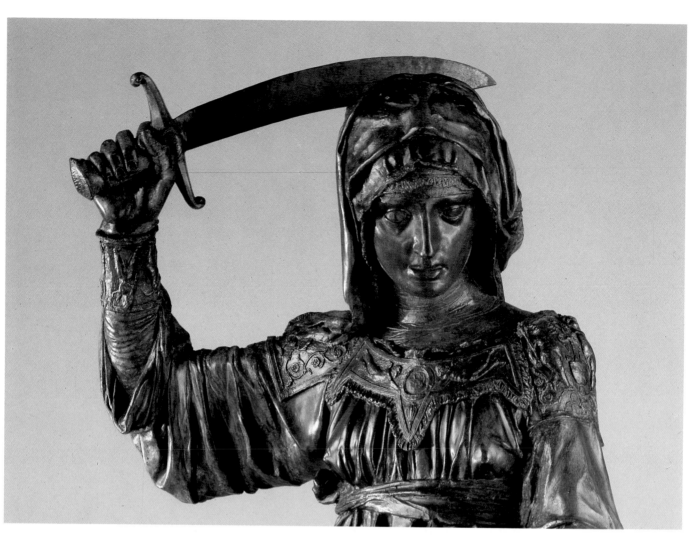

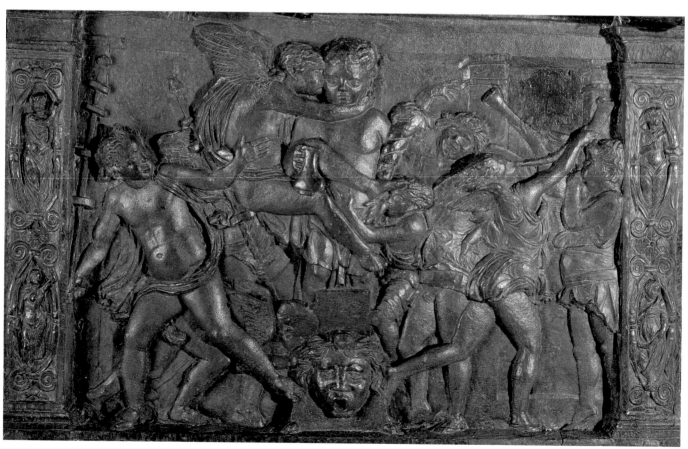

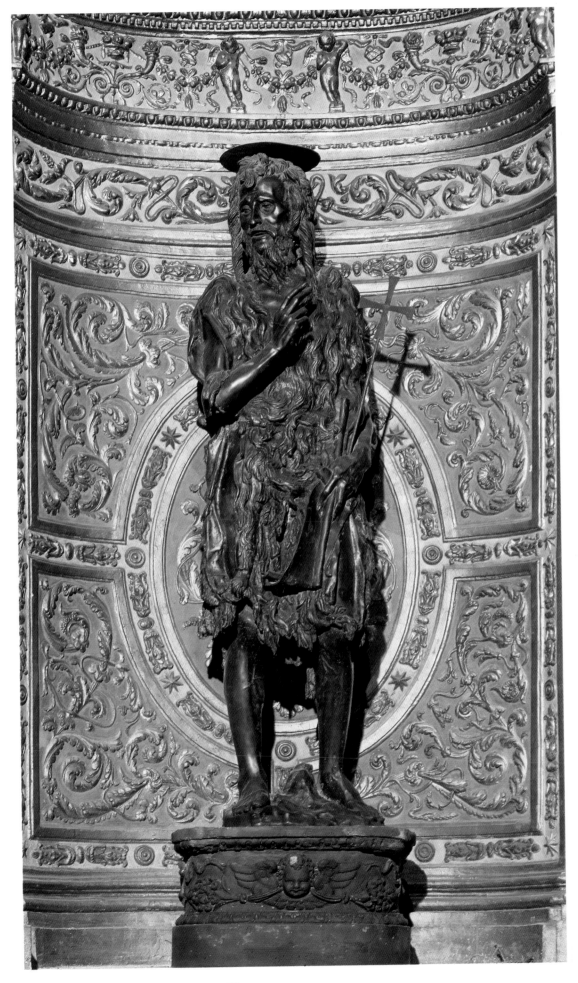

*91-93. Judith
and Holofernes
(after restoration)
h. 236 cm
Florence, Palazzo
Vecchio*

*94. St John the
Baptist
h. 185 cm
Siena, Cathedral*

proof of Donatello's interest in multiple reproductions, which were subsequently made in glass.

A comparison between the rendering of the drapery in the *Lamentation over the Dead Christ* of the London Victoria and Albert Museum, and that of the *Chellini Madonna*, would suggest that this bronze — whose chronology is disputed by scholars — belongs to the same period.

The last work, the two *Pulpits* in the Basilica of San Lorenzo — whose chronology we owe to Giovanni Previtali, who found the date *1465 adì 15 Gug* (on 15 June 1465) traced on the ledge of the pulpit to the left of the *Torture of St Lawrence* — are obviously the result of collaboration between Donatello and his pupils Bertoldo and Bellano. While in the *Deposition from the Cross* and the *Entombment* this collaboration is apparent — in the extremely elongated figures and the unusually high degree of finish of the reliefs — the *Agony in the Garden* is considered to be the part where Donatello was working alone and where his ties to his youthful style are clearly visible. Everything is permeated by Ghiberti, from the landscape to the soft line connecting the images and the groups of sleeping disciples, each one clearly defined.

It is the general consensus of art historical opinion that in these eleven panels the collaboration of the pupils played a prominent part. The bas-reliefs were first modelled in wax, and it is probable that for as long as he could, Donatello carried out this process himself. But by degrees a progressive paralysis must have limited his direct participation, forcing him to give a free hand to his helpers, though he may have continued to direct them. When he died on 13 December 1466 the two pulpits were not in place, and their final positioning, which followed a sketch made by Donatello, did not occur until 1515, when Pope Leo X visited Florence.

The debated *Crucifixion* in the National Museum of the Bargello is from the same period as the Pulpits for San Lorenzo. Despite Vasari having cited the work it has been attributed to various hands, even if it undoubtedly reflects an idea from the master's last years.

Vasari's appraisal of Donatello at the end of his biography is a valid one even today, and worthy of consideration. *The world remained so full of Donatello's works that it may be said with confidence that no artist has ever produced more than he did. He delighted in everything, and so he tried his hand at everything, without worrying whether what he was doing was worthwhile or not. Nevertheless, this tremendous activity of Donatello's, in every kind of relief, full, half, low,*

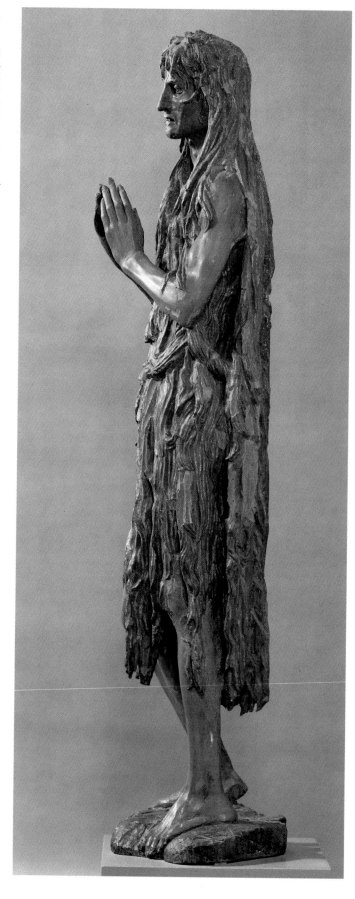

95, 96. St Mary Magdalen (after restoration) h. 188 cm
Florence, Museum of the Opera del Duomo

70

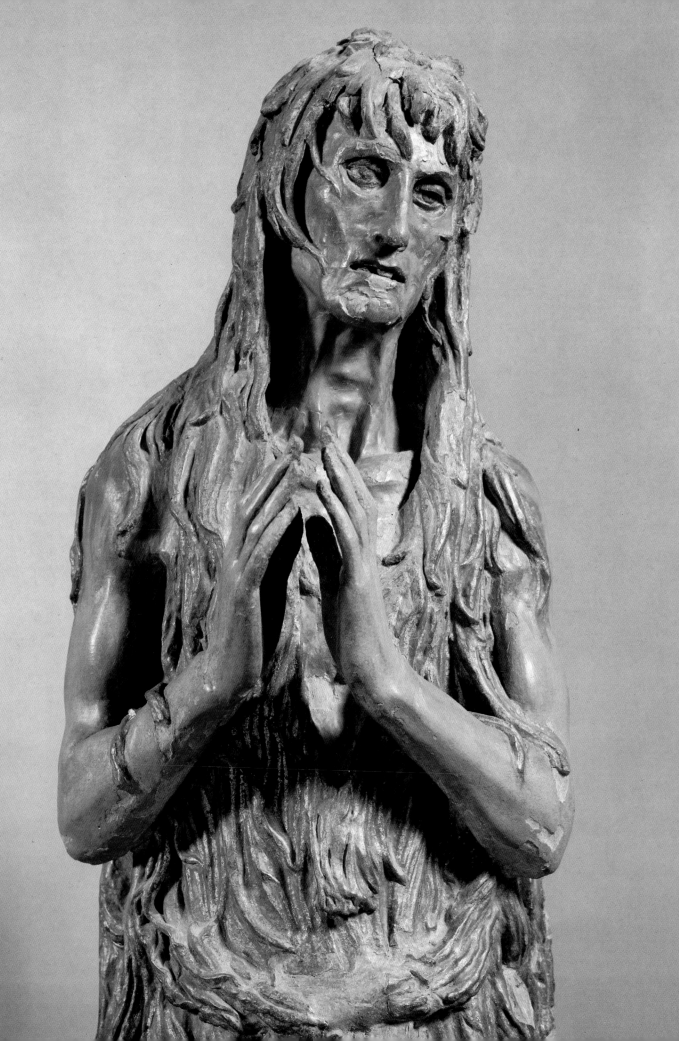

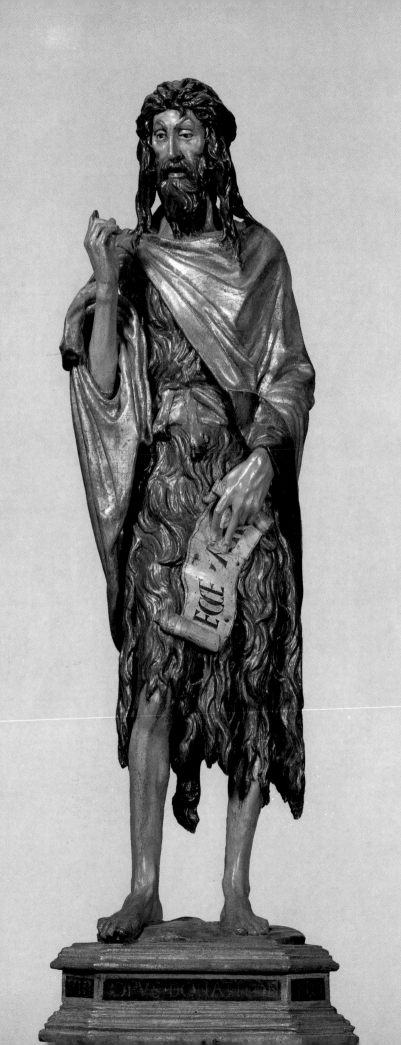

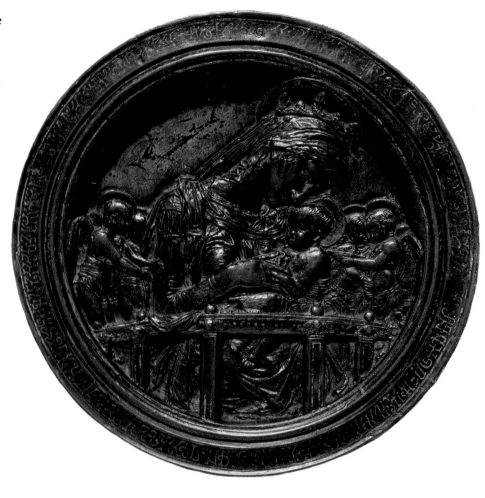

97. St John the Baptist (after restoration) h. 141 cm Venice, Church of Santa Maria Gloriosa dei Frari

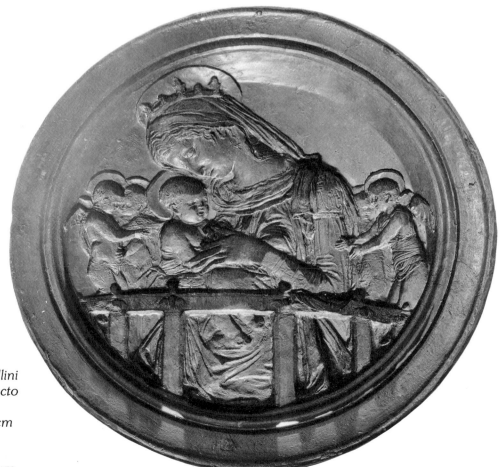

98, 99. Chellini Madonna, recto and verso diam. 28.5 cm London, Victoria and Albert Museum

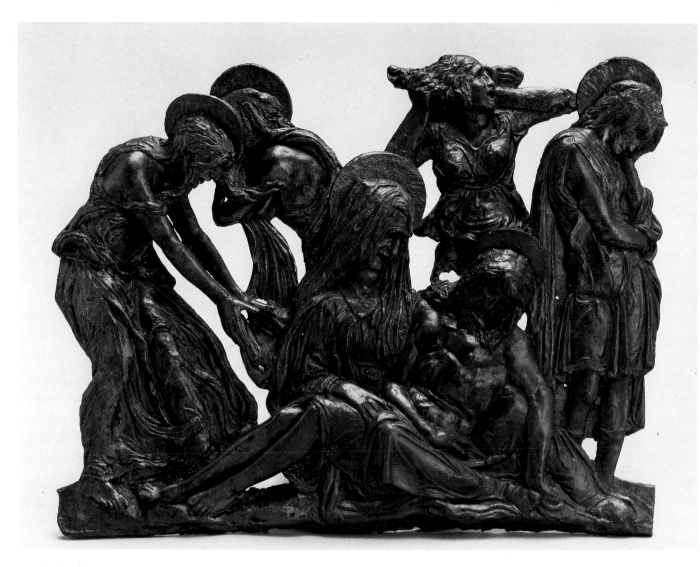

and the lowest, was indispensable to sculpture. For whereas in the good times of the ancient Greeks and Romans sculpture was brought to a state of perfection by many hands, he alone by his many works restored its magnificence and perfection in our own age. Artists should, therefore, trace the greatness of the art back to him rather than to anyone born in modern times. For as well as solving the problems of sculpture by executing so many different kinds of work, he possessed invention, design, skill, judgement, and all the other qualities that one may reasonably expect to find in an inspired genius... Aut Donatus Bonarrotum exprimit et refert, aut Bonarrotus Donatum. (Either the spirit of Donato continues to work in [Michelangelo] Buonarroti or that of Buonarroti began to work before his time in Donato).

100. Lamentation over the Dead Christ
33.5 x 41.5 cm
London, Victoria and Albert Museum

101. Crucifixion
93 x 70 cm
Florence, National Museum of the Bargello

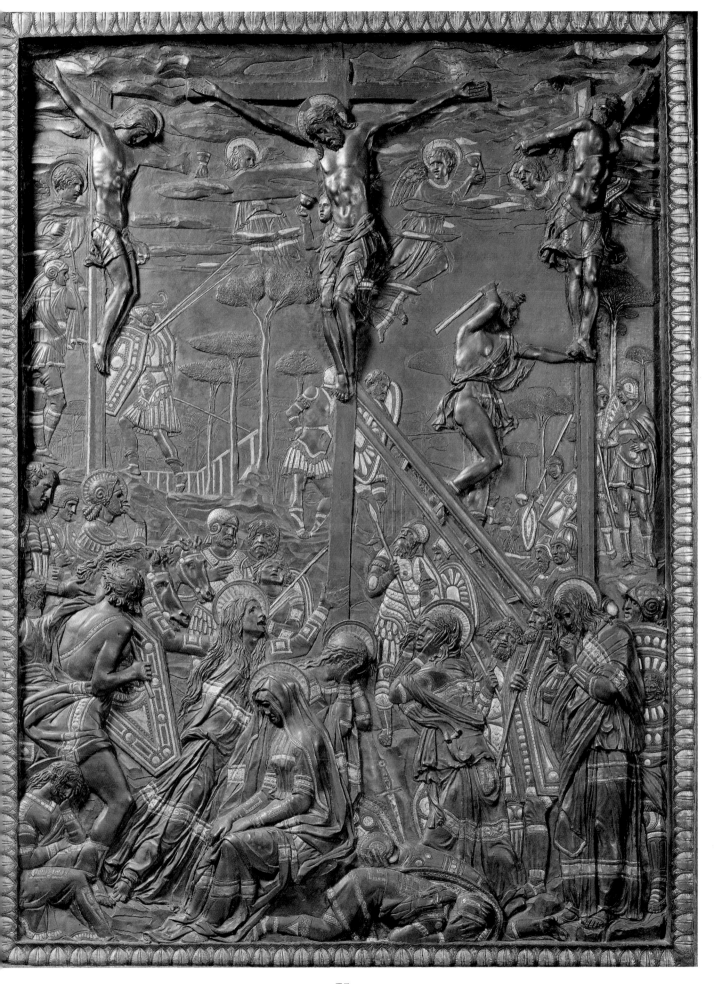

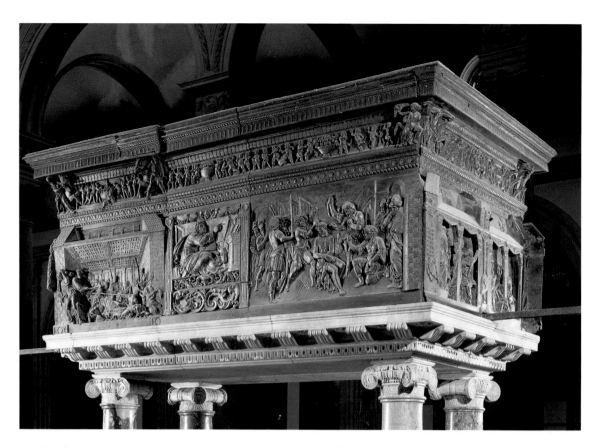

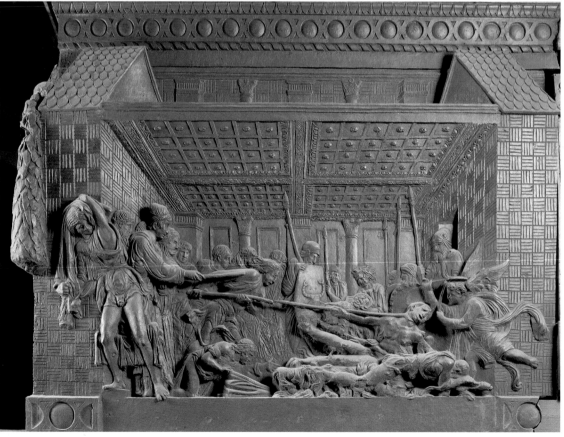

*102, 103. Pulpit on the right and detail
representing the Torture of St Lawrence
123 x 292 cm
Florence, Church of San Lorenzo*

*104, 105. Pulpit on the left and detail
representing the Entombment
137 x 280 cm
Florence, Church of San Lorenzo*

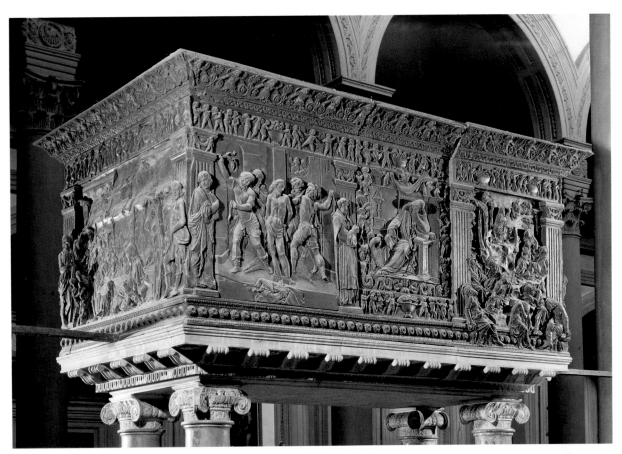

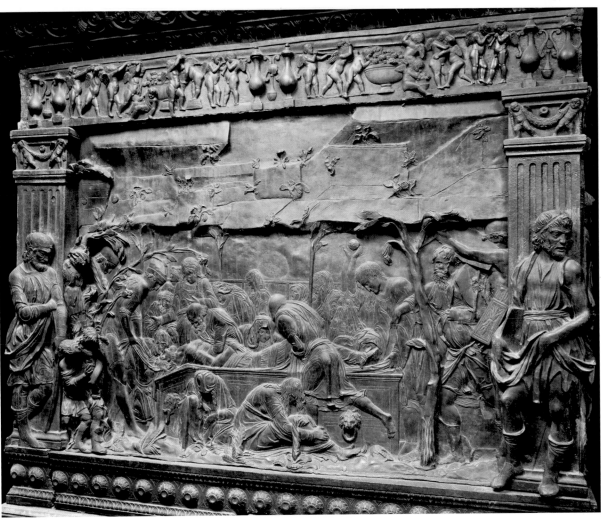

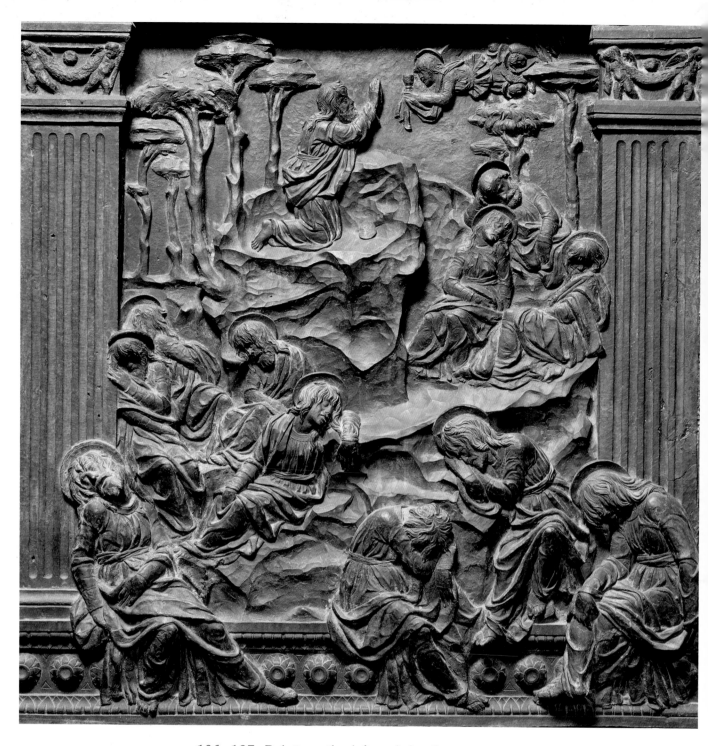

*106, 107. Pulpit on the left and details representing
the Agony in the Garden and the Deposition
Florence, Church of San Lorenzo*

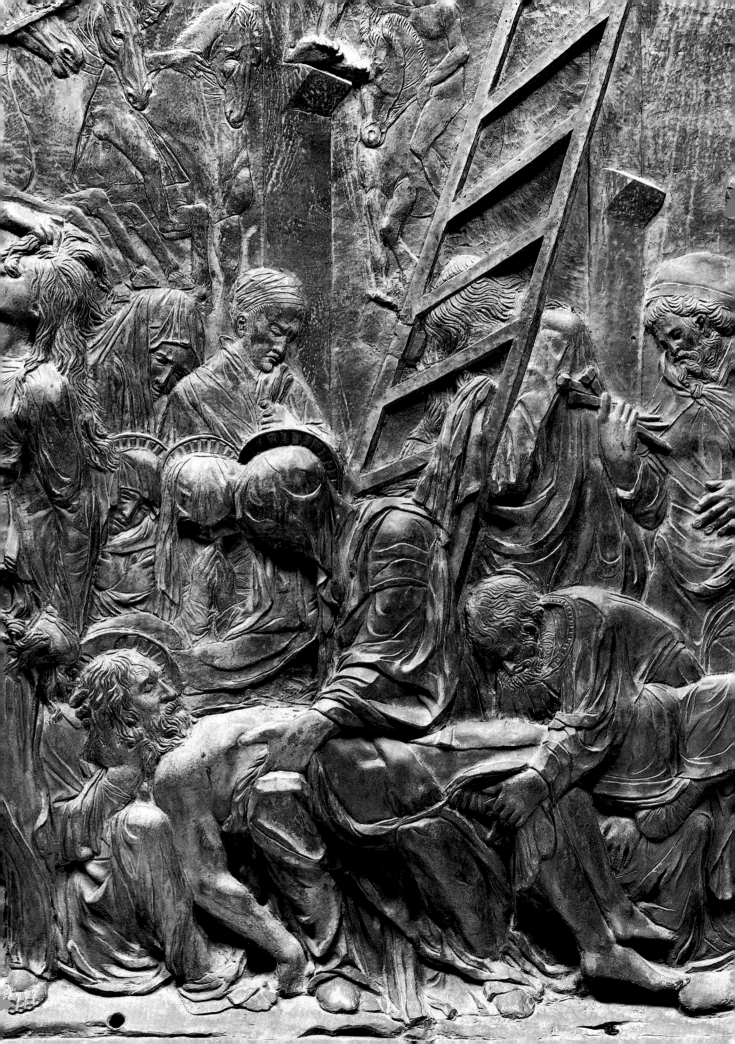

Short Bibliography

A. BILLI, *Il libro di Antonio Billi*, (1530 ca.), Berlin 1892.
Magliabechi Manuscripts, (c. 1550), Naples 1968.

M. A. MICHIEL, *Notizie d'opere di disegno*, (c. 1550), Bologna 1884.

G. VASARI, *Le Vite de' più eccellenti pittori scultori e architettori* nelle redazioni del 1550 e 1568, III, Florence 1971. Translation from: *The Lives of the Artists*, London 1987.

A. VENTURI, *Storia dell'arte italiana VI: la scultura del Quattrocento*, Milan 1908.

A. COLASANTI, *Donatello*, Rome [1927].

L. PLANISCIG, *Piccoli bronzi italiani del Rinascimento*, Milan 1930.

L. PLANISCIG, *I profeti sulla porta della Mandorla del Duomo fiorentino*, in "Rivista d'Arte", XXIV, 1942, pp. 125-142.

L. PLANISCIG, *Donatello*, Florence 1947.

H.W. JANSON, *The Sculpture of Donatello*, Princeton 1957.

L. GRASSI, *Tutta la scultura di Donatello*, Milan 1958.

J. POPE-HENNESSY, *La scultura italiana: il Quattrocento*, II (1958), Ital. translation, Milan 1964.

G. FIOCCO, *L'altare grande di Donatello al Santo*, in "Il Santo", I, 1961, pp. 21-36.

G. PREVITALI, *Una data per il pulpito di San Lorenzo*, in "Paragone", 133, 1961, pp. 48-56.

G. CASTELFRANCO, *Donatello*, Milan 1963.

A. PAOLUCCI, *Donatello*, in "I Maestri della scultura", 31-32, Milan 1966.

L. BECHERUCCI and G. SINIBALDI, *Il Museo dell'Opera del Duomo a Firenze*, I, Venice 1969.

AA.VV., *Omaggio a Donatello 1386-1986*, exhibition catalogue, Florence 1985.

AA.VV., *Donatello e i Suoi. Scultura fiorentina del primo Rinascimento*, exhibition catalogue, Florence 1986.

AA.VV., *Donatello e la Sagrestia Vecchia di San Lorenzo*, Florence 1986.

J. POPE-HENNESSY, *Donatello*, Florence 1986.

AA.VV., *Donatello e il restauro della Giuditta*, Florence 1988.

L. BERTI and A. PAOLUCCI, *L'età di Masaccio. Il primo Quattrocento a Firenze*, exhibition catalogue, Florence 1990.

A. GIUSTI, *Sculture da conservare. Studi per una tecnologia dei calchi*, Florence 1990.

Index of the Illustrations